WISDOM

智

EX LIBRIS

Karen Mijal

CowParade Stamford

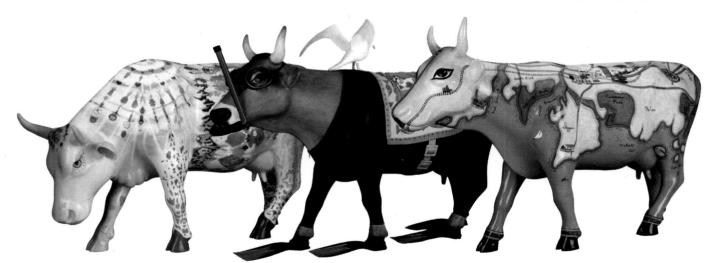

WORKMAN PUBLISHING • NEW YORK

Library of Congress Cataloging-in-Publication Data is available

ISBN 0-7611-2293-1

CowParade is a registered trademark of CowParade Holdings Corporation.

Workman books are available at special discounts when purchased in bulk for
premiums and sales promotions as well as for fund-raising or educational use.
Special editions or book excerpts can also be created to specification.
For details, contact the Special Sales Director at the address below.

Workman Publishing Company, Inc.
708 Broadway
New York, NY 10003-9555
www.workman.com

Printed in the United States of America

First printing July 2000
10 9 8 7 6 5 4 3 2 1

Dear Friends:

It is my pleasure to welcome you to CowParade Stamford 2000. CowParade is a wonderful display of public art that has been entertaining all those who work and live in Stamford since its arrival in June. This book, based on the exhibition, will enable us to continue to enjoy it after the cows have gone home.

Stamford is an ideal place for this herd of brightly and cleverly decorated cows to graze. For the past six years, Stamford has supported one of the most prestigious public art programs in the nation. CowParade is yet another reminder of the pride Stamford residents take in art, our local artists, and the strength and support Stamford businesses offer our community.

The cows from the Stamford CowParade will be loved and admired, played with and spoken about all summer. In the fall we will host an event at which time they will be auctioned off for the benefit of local charities.

Thank you for supporting and enjoying this delightful exhibit.

Sincerely,

Dannel P. Malloy
Mayor

Portrait of Mayor
Malloy painted by
John Stevens from his
cow *Mayor Moolloy*

Dear Readers,

Welcome to *CowParade Stamford.* What you will see on the following pages are the marvelous artistic creations of a number of very gifted Stamford and Connecticut artists, from the well-known to the young and aspiring.

CowParade is, first and foremost, a public art event. It is intended to make accessible for viewing by people of all ages imaginative, artistic works in a variety of styles. Why the cow?

The cow is a wonderful three-dimensional canvas for the artist. It is the right length and height, has a generous surface area, and has a striking bone structure. More importantly, the cow is an animal we all like and to which the artist can easily relate. One of the first words we may learn as an infant is "moo." The cow is a source of milk that nourishes our bodies, and which is a basic ingredient in such delectables as ice cream and chocolate. The cow—friendly, quirky, and whimsical—is an animal that inspires the artist and delights the viewer.

CowParades are being presented in New York City and West Orange, New Jersey at the same time as the Stamford exhibit. Future events are planned for Hawaii, Kansas City, and Houston as well as London, Sydney, and Johannesburg. You can find the most up-to-date information about CowParade on our website: *http://www.cowparade.net*

CowParade wishes to extend its appreciation to Sandy Goldstein and Mayor Dannel Malloy of Stamford, who worked so hard with their colleagues to make CowParade Stamford 2000 successful. Very special thanks to my son, Steven Elbaum, whose initiative and persistence resulted in Stamford's inclusion in this year's CowParade.

Jerry Elbaum
President, CowParade Holdings Corporation
West Hartford, Connecticut

Dear Friends,

It is with great pleasure that we present this year's sculpture event, CowParade Stamford 2000. Since 1994 the City of Stamford has embraced a sculpture exhibition dedicated to recognizing art as a catalyst for public interaction and enrichment. The CowParade exhibit has perfectly fulfilled our mission.

The excitement of the event can be witnessed in the faces of people all over Stamford Downtown and in Stamford Town Center. It is a delight to watch the children of our community "milking" our colorful cows and posing for pictures. The 67 beautiful bovines have quickly become cornerstones of the community, and we are grateful to the countless people who have made this event possible.

Special thanks to our artists for their creative and wonderful visions and to our generous sponsors who made the cows come to life. Our appreciation to the office of the Speaker of the House, Moira K. Lyons, and the State of Connecticut. Thanks especially to Mayor Dannel Malloy and the City of Stamford's Operations Team, whose support for events such as this truly makes Stamford the City That Works.

It is our sincere hope that you enjoy this commemorative book as much as we have enjoyed presenting CowParade Stamford 2000.

Sincerely,

Sandy Goldstein

Sandy Goldstein
Executive Director
Stamford Downtown
Special Services District

Robert Kahn
Chairman
Stamford Downtown
Special Services District

Al Messer
General Manager
Stamford Town Center

Introduction

I n 1994 the city of Stamford and an enthusiastic group of corporate sponsors inaugurated the Stamford Sculpture Walk, an annual event that has brought fine art into public spaces. With that type of civic commitment to art in the open air, it was only natural that Stamford would welcome CowParade.

The artists who took cows for their canvases range from Mark Garro, a fantasy illustrator for books by such authors as R. L. Stine; cartoonist and graphic designer Chuck Barnard, who based his cow on a card he drew for a friend many years ago; Robyn Isaacs, whose work reflects her dedication to environmental issues; and Sandy Garnett, who has been exploring the concept of identity through his series of fingerprint paintings. Recalling the old nursery rhyme about the cow that jumped over the moon, Jan Raymond came up with the fanciful *Moo Beam,* while Angela

China Cow, see page 70

The Bovine Timeline

c. 4000 B.C.
The first cheese is made in Switzerland.

c. 3000 B.C.
Queen Hete-Phere of Egypt accepts the honorary title "Guardian of the Corporation of Butchers."

c. 500 B.C.
Darius, a Persian gourmand, gives the first banquet for which the main course is a roasted whole ox.

c. 850
Vikings bring the ancestors of British White cattle to England.

1029
The Norse king Sitric hands over 1,200 cows to ransom his son, Olaf.

c. 5000 B.C.
Farmers in Greece, Turkey, and Crete start domesticating wild cattle.

c. 3500 B.C.
Butter is invented in Sumeria.

c. 2000 B.C.
When three angels appear at Abraham's tent, he serves them butter, milk, and a fatted calf.

c. A.D. 100
An anonymous poet creates The Tain, Ireland's national epic about a war that started over a cattle raid.

960
Monks from Brittany introduce the first dairy cows to the island of Guernsey.

1493
The first cattle in the New World come ashore with Christopher Columbus on the island of Hispaniola.

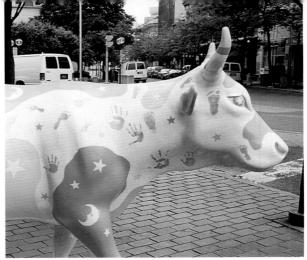

Loeffel Burns's *China Cow* pays tribute to her favorite art teacher, the great Georgia O'Keeffe. And 78 patients, family members, staff, and volunteers of the Bennett Cancer Center came together to create *Udderly Groovy Lady Belle Bennett*.

As you'll see, many of the cows are Stamford-centric. Michael and Francine Funke's *The Cow That Works—From Stamford, The City That Works,* is covered with interlocking gears to suggest how smoothly their city is operating in the present and how swiftly it is moving into the future. Marcele A. Mitscherlich's *Lo-Cow-Motion* and Jody Silver Schwartz's *Cowmuter* salute Stamford residents who commute to New York City. John Stevens's *Mayor Moolloy* pays tribute to Stamford's mayor. And Lina Morielli's *Miracles—The*

CowParade flyers herald the arrival of the herd.

Miracles—The Special Delivery Cow, see page 49

1570s
Every Sunday afternoon, Queen Elizabeth I of England attends a bull- or a bear-baiting.

1521
The first longhorn cattle arrive in Mexico with Cortés.

1611
The first cows in English North America arrive at Jamestown.

1624
Devon cattle arrive at Plymouth Colony.

1779
Joseph Corree of New York City begins home delivery of ice cream.

1846
The first cattle drive on record travels from Texas to Missouri.

1856
Louis Pasteur begins experiments in what will be known as pasteurization.

1856
Gail Borden receives a patent for condensed milk.

1860
A census shows that there are 31 million people in the United States—and 26 million heads of cattle in Texas.

1878
Dr. Gustav DeLaval invents the centrifugal cream separator.

Special Delivery Cow is printed with the hands and feet of boys and girls who had been cared for in the neonatal unit of Stamford Hospital and are now thriving.

The emphasis on public art is only one facet of Stamford's renaissance. One hundred years ago, Stamford's major employer was the Yale & Towne factory, where locks were made. Today Stamford is a financial center, headquarters for a long list of prestigious corporations, and home to hundreds of commuters who take the train to jobs in New York City.

Stamford is one of those rare cities that is at once urban, suburban, and rural. From vibrant Downtown, it's only a short drive to the city's parks and beaches on the Long Island Sound, or to the beautifully wooded residential area of North Stamford. This is a dynamic, prosperous, forward-looking city that has not lost its amiable small-town feel.

Streetsmart Cow,
see page 16

1884
Dr. Harvey Thatcher of Potsdam, New York, invents the milk bottle.

1908
Chicago passes the first compulsory pasteurization law.

1911
The automatic rotary milk bottle filler and capper is perfected.

1919
Torrington, Connecticut, becomes the first town in America to sell homogenized milk.

1929
Walt Disney's Clarabelle Cow makes her debut in the animated cartoon *The Plow Boy.*

1933
Four Guernsey cows make the trip to Antarctica with Admiral Richard Byrd.

1938
Bulk tanks begin to replace the old milk cans.

1948
The first plastic-coated paper milk cartons are introduced.

1961
A British Friesian cow gives birth to the heaviest live calf ever. The newborn tips the scales at 225 pounds.

1993
Big Bertha, a Dremon cow, dies at age 48 years and 9 months. She was the oldest cow on record.

Lo-Cow-Motion

ARTIST: **Marcele A. Mitscherlich**
PATRON: **Louis Dreyfus Property Group**
LOCATION: **Latham Park**

The bovine answer to Metro North, this Mootro-North train demonstrates how vital the railroad is to Stamford's many commuters. Miniature cows recline in elegant comfort in the belly of the big beast, visible to passersby through a Plexiglas window. A button on the rear end, when pressed, prompts the cow to emit a long "Mooo" to let people know the chuck wagon is on the way.

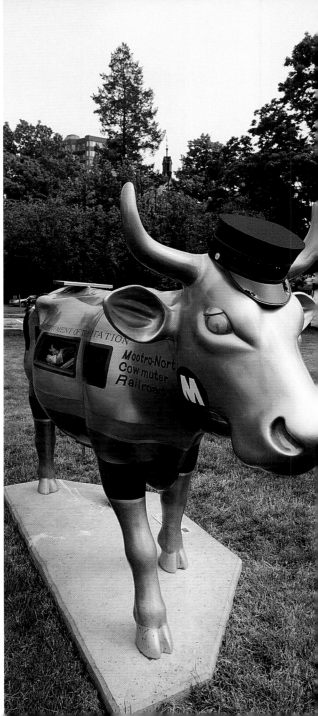

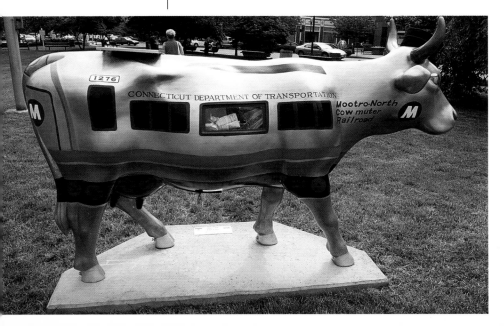

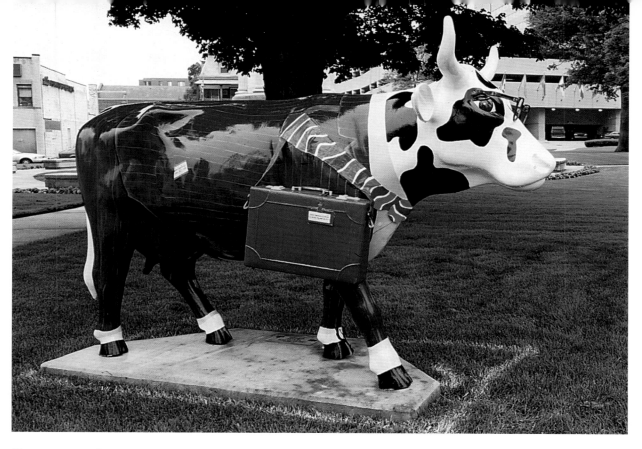

Cowmuter

ARTIST: **Jody Silver Schwartz**
PATRON: **Robinson & Cole LLP**
LOCATION: **St. John's Park (at Tresser Boulevard and Grove Street)**

Stamford is a big commuter town, with many people taking the train to nearby New York City every morning, as well as a reverse commuter town, with some New Yorkers riding to work in Stamford's thriving business center. It is no wonder, then, that there is a *Cowmuter* in Stamford's herd. He is rushing for his train, the wind blowing his tie to the side. Conservatively attired in a blue pinstripe suit, *Cowmuter* comes prepared with a newspaper tucked under one arm and a big briefcase strapped over the other shoulder. This cow is all business, so moove out of the way.

HOLSTEIN HALL OF FAME

Raim Mark Jinx of Cedaredge, Colorado, produced 60,440 pounds of milk in one year.

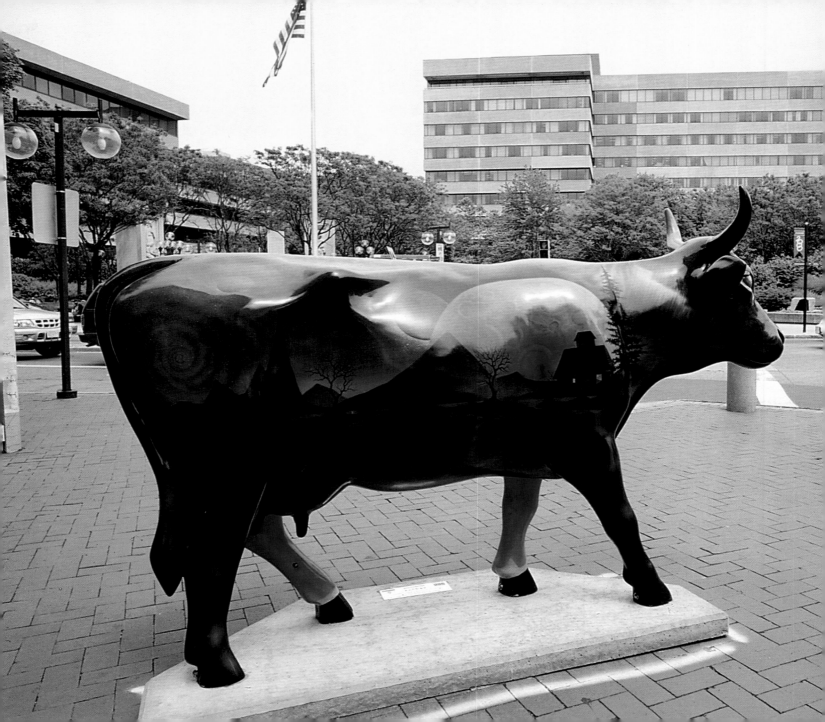

Moother Earth/Blue Mooon Under Milky Ways
(left and top right)

ARTIST: **Mark Garro**
PATRON: **Stamford Health System**
LOCATION: **Corner of Main and Atlantic Streets**

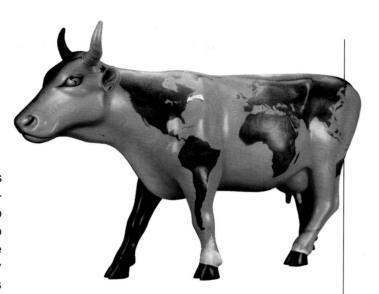

As a fantasy illustrator for books by authors like R. L. Stine, Mark Garro is used to working on much smaller surfaces than the two cows he painted for CowParade. "I was also surprised when I came to work on the face of *Moother Earth/Blue Mooon Under Milky Ways,*" he says, explaining that the sketches he had prepared for his cows only took into consideration the two broad sides. When he looked at the face, he was inspired to drape it with trompe l'oeil jewelry. After he finished painting he noticed the cow had a kind of Hindu look to her. "I hadn't intended for that to happen, but I guess it makes sense, given the cow's sacred status in India."

Plant Earth
(lower right)

ARTIST: **Mark Garro**
PATRON: **Stamford Town Center**
LOCATION: **Stamford Town Center**

Cow-A-Bunga!
(below)

ARTIST: **Chuck Barnard**
PATRON: **Stamford Town Center**
LOCATION: **Stamford Town Center**

Cartoonist and graphic designer Chuck Barnard drew a cartoon of a surfing cow shouting "Cowabunga!" on a greeting card for a friend years ago. When the opportunity came to participate in CowParade, he couldn't resist bringing his old character back. *Raqcow Welch* gave him the opportunity to lend a stocky bovine the glamour of a favorite movie star.

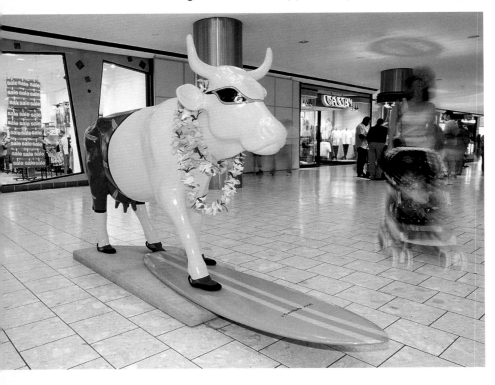

HOW TO SAY COW IN TEN LANGUAGES

1. Danish: *Koe*
2. German: *Kuh*
3. Polish: *Krowa*
4. Serbian: *Crava*
5. French: *Vache*

6. Italian: *Vacca* or *Mucca*
7. Spanish: *Vaca*
8. Japanese: *Ushi*
9. Indonesian: *Sapi*
10. Korean: *So*

Raqcow Welch
(right)

ARTIST: **Chuck Barnard**
PATRON: **Stamford Town Center**
LOCATION: **Stamford Town Center**

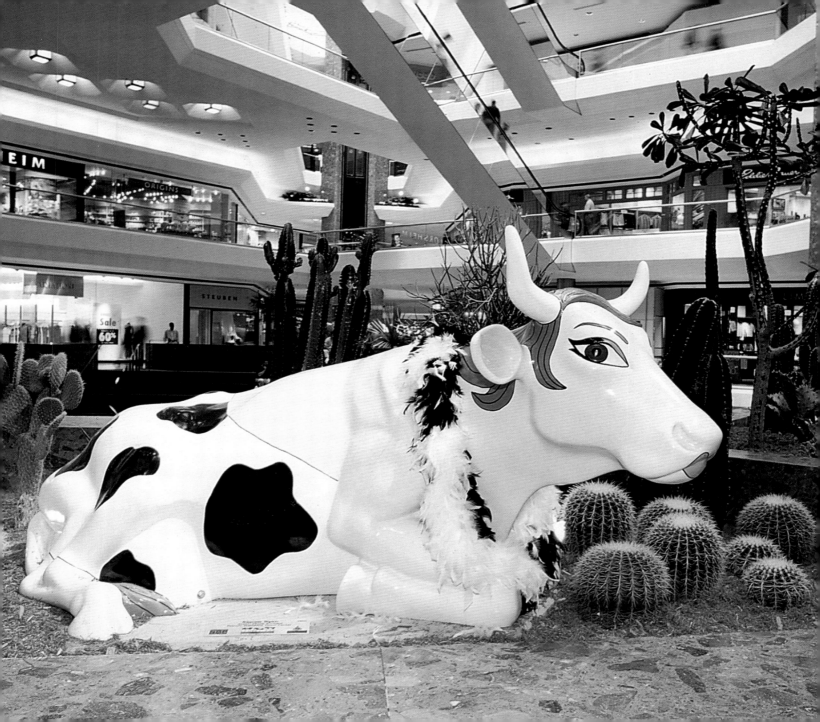

RECORD-SETTING COWS

The Tallest Cow: Chianina, stands six feet high.

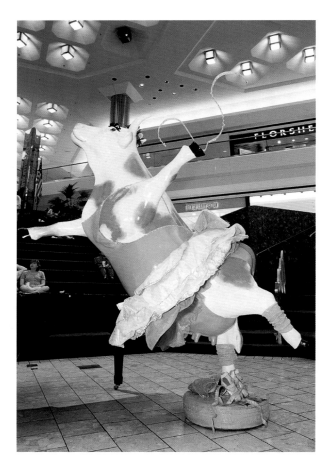

Twinkle Toes

ARTIST: **Silvia Fernandez-Stein**
PATRON: **Stamford Town Center**
LOCATION: **Stamford Town Center**

Silvia Fernandez-Stein is the coordinator of the Urban Arts Initiative in Stamford. Born in Santiago, Chile, she began formal study in sculpture at the School of Fine Arts at the University of Chile before being exiled in 1976. In addition to teaching art, Fernandez-Stein is a dance teacher and choreographer. *Twinkle Toes* represents the combination of her love of dance and sculpture. Fernandez-Stein says that one of the most gratifying things about working on the project has been seeing people's responses to the cows. The children try to stand on tiptoe with their arms above their heads in the pose of the cow. And adults who find themselves looking at it at the same time end up talking to one another. "That, to me," the artist says, "is the creation of a community."

 COW LORE

If a cow stands with her back to the wind, it's about to rain.

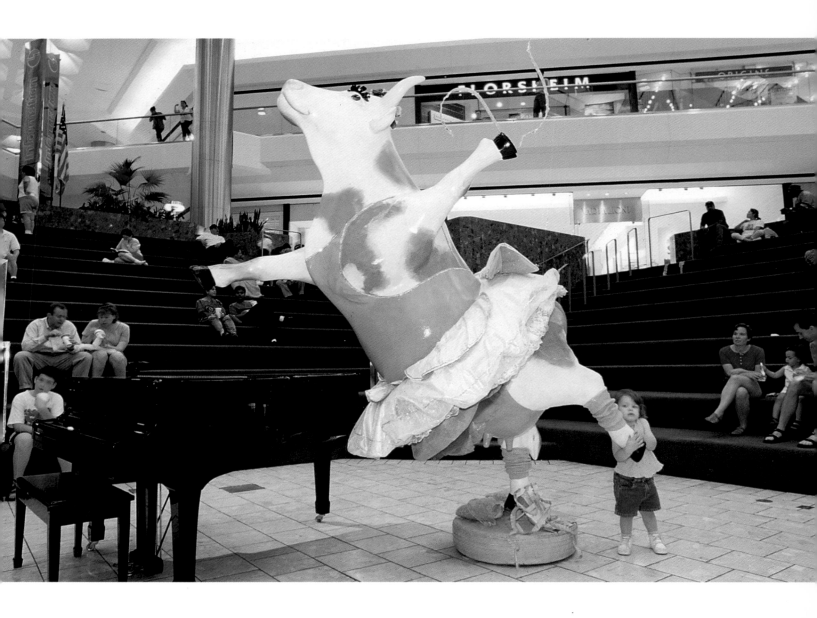

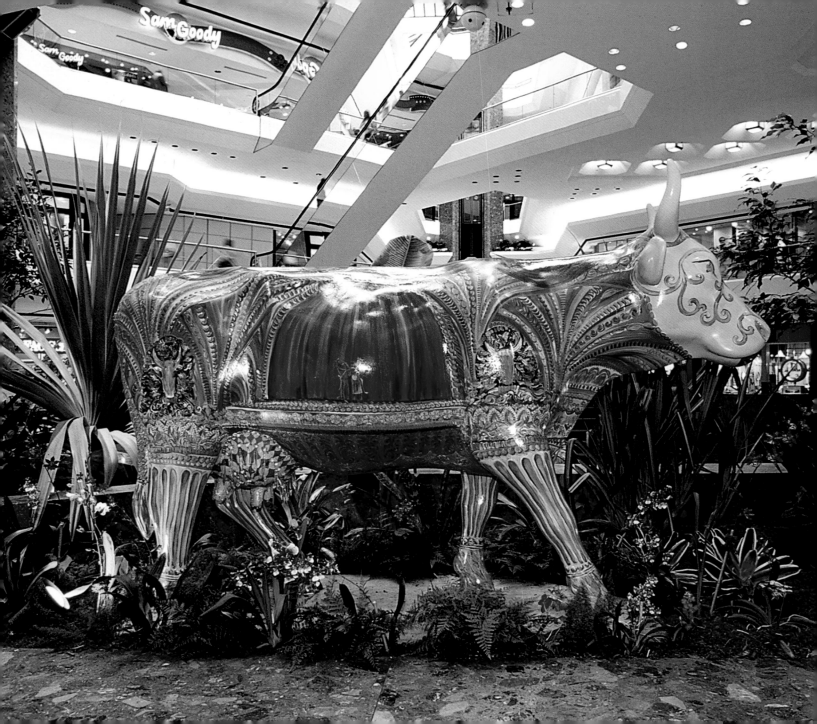

Opera Cow "La Bovène"

ARTIST: **Susan Mastropietro**
PATRON: **PanAmSat Corporation**
LOCATION: **Stamford Town Center**

Just as opera is made up of many diverse elements such as music and song, ornate costumes, and elaborate sets, the cow provides a wide array of life-affirming staples like hides, meat, and milk. *Opera Cow "La Bovène"* celebrates the cow's bounty as well as its beauty.

Detail from *Opera Cow "La Bovène"*

"THE COW"
by Ogden Nash

The cow is of the bovine ilk;
One end is moo, the other, milk.

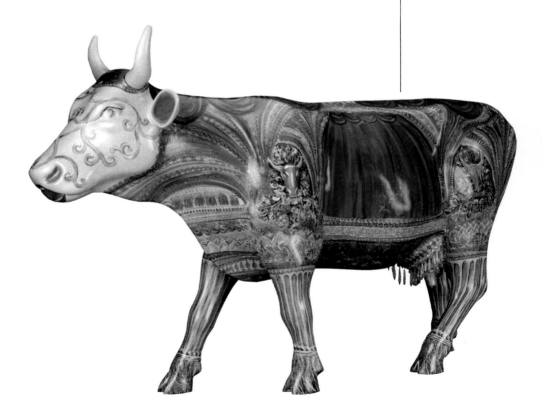

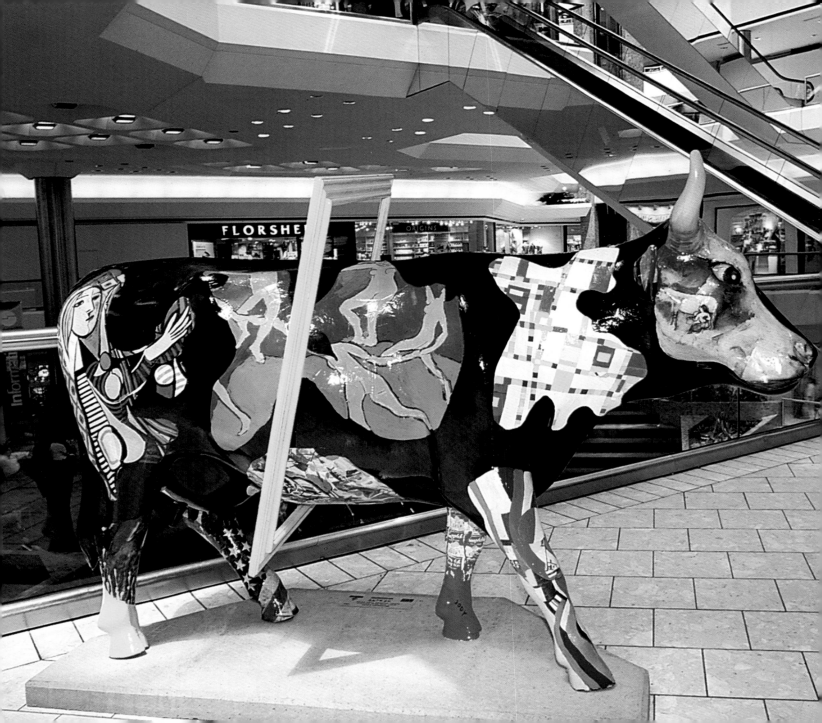

Mooseum Lover

ARTIST: **Jody Silver Schwartz**
PATRON: **Stamford Town Center**
LOCATION: **Stamford Town Center**

Mooseum Lover is a sort of "greatest hits" of the modern and contemporary art world. It features Campbell's Soup cans in honor of Andy Warhol, a Jim Dine heart, a swirl of van Gogh's *Starry Night,* Jasper Johns's *American Flag,* an illustration in the style of Lichtenstein, and a splatter of paint for Jackson Pollock, among other highlights.

 HOLY COWS!: CRETE

Pasiphae, queen of Crete, conceived a bizarre passion for a magnificent bull. Their union produced the Minotaur, a creature with the body of a man and the head of a bull. King Minos, Pasiphae's unhappy husband, hid the Minotaur from sight in the Labyrinth. To pacify the monster, every year Minos fed it seven handsome young men and seven beautiful young women from Athens. One year Theseus offered himself as one of the victims. With the help of Ariadne, Minos' daughter, Theseus killed the Minotaur and escaped from the Labyrinth.

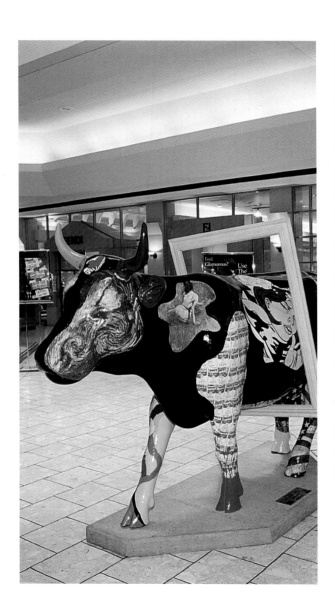

HOLSTEIN HALL OF FAME

Twin-B-Dairy Aerosta Lynn of Wausau, Wisconsin, produced 63,444 pounds of milk in one year.

Surf and Turf

ARTIST: **Pamela Riley Abear**
PATRON: **Robinson & Cole LLP**
LOCATION: **St. John's Park**
(at Tresser Boulevard and Grove Street)

Pamela Riley Abear has always lived by the water, loving the ocean and having a particular fondness for fish. *Surf and Turf* reflects her interests and her talents as a realist painter whose work includes murals and house portraits. In a sentiment echoed by several other artists in the show, Abear notes that it is very difficult to go shoe shopping for cows.

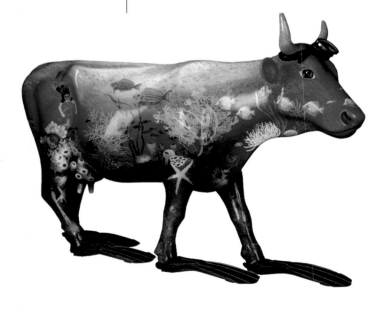

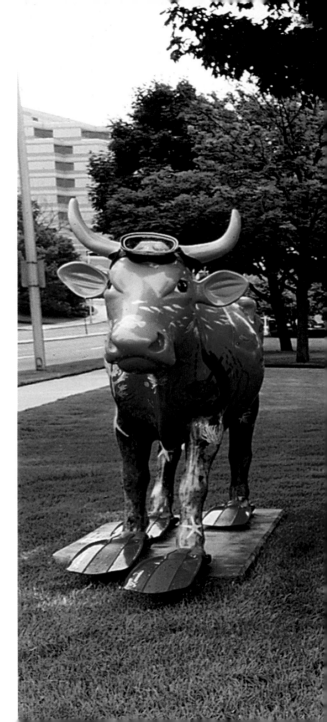

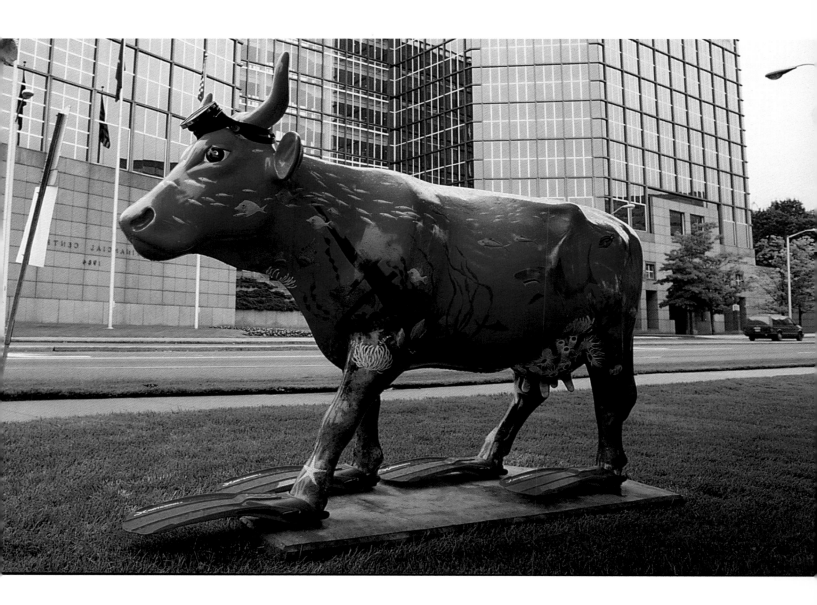

KEY COW FACTS

A cow has four stomachs. The first, the rumen, or paunch, is where the food goes when a cow swallows. Once the rumen has softened up the food, it is regurgitated to be chewed as cud. When the cow swallows the cud, it goes to the second stomach, the reticulum, or honeycomb. The process of swallowing, regurgitating, and chewing cud is repeated in the third stomach, the omasum, or manyplies, until at last the food is digested in the fourth stomach, the abomasum.

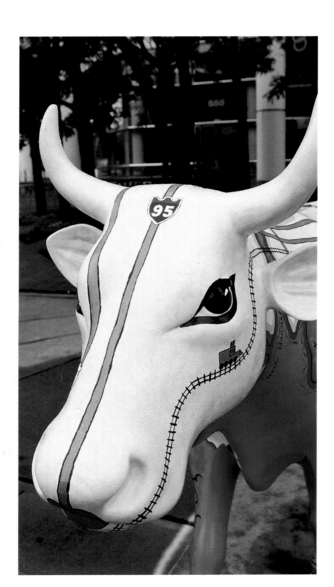

Streetsmart Cow
ARTIST: **Allison Beispel**
PATRONS: **JHM Financial LLC and The Richmond Group of Connecticut, LLC**
LOCATION: **Government Center (at Tresser and Washington Boulevards)**

Streetsmart Cow celebrates Stamford's strengths, both natural and man-made. This map of the area shows the generous shoreline with its inlets and harbors, the thriving downtown area, and the train that connects Stamford to New York and New England.

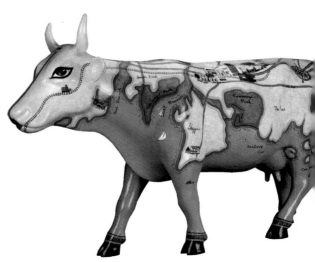

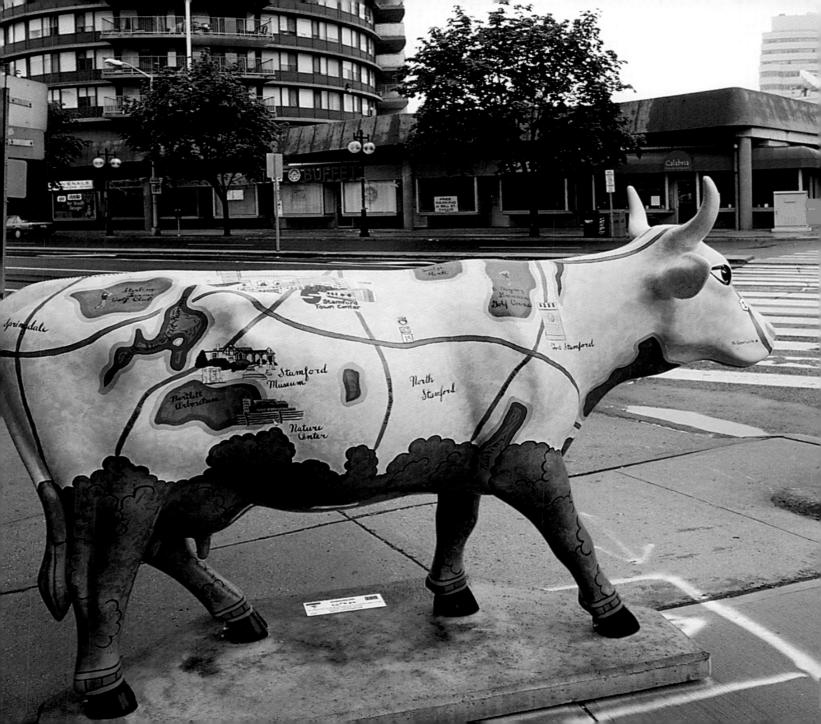

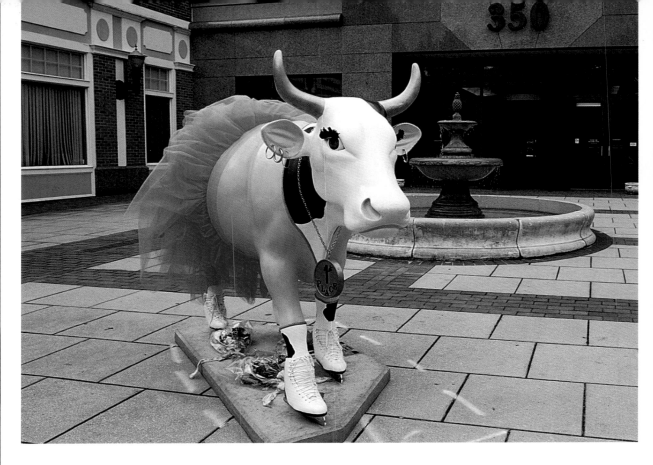

A Triple Sal Cow

ARTIST: **Nina Bentley**
PATRON: **People's Bank**
LOCATION: **People's Bank Plaza (350 Bedford Street)**

"A 'salchow' is a kind of ice-skating jump that has always reminded me of cows because of its pronunciation, 'sow cow,'" says assemblage artist Nina Bentley. *A Triple Sal Cow* is a champion. In addition to her pink skating ensemble, complete with tutu and ice skates, she wears a gold medal.

The cow offered a unique challenge—finding appropriate footwear. As Bentley explains, "It took me about two minutes to draw the skates for the proposal, but to get the skates on took two weeks."

DID YOU KNOW?

A mature Holstein cow weighs about 1,500 pounds and stands 58 inches tall at the shoulder.

Georgia O'Cow

ARTIST: **Margot Bittenbender**
PATRON: **Emmett & Glander, Attorneys at Law**
LOCATION: **45 Franklin Street**

Georgia O'Cow is decorated with flowers, clouds, and abstract designs, all inspired by the work of renowned painter Georgia O'Keeffe. The artist, Margot Bittenbender, teaches art in Greenwich and finds that the children love and understand O'Keeffe's work.

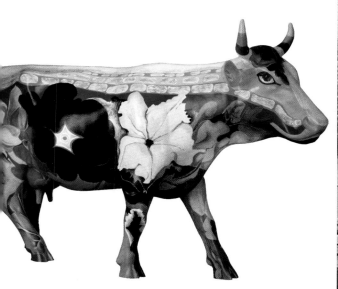

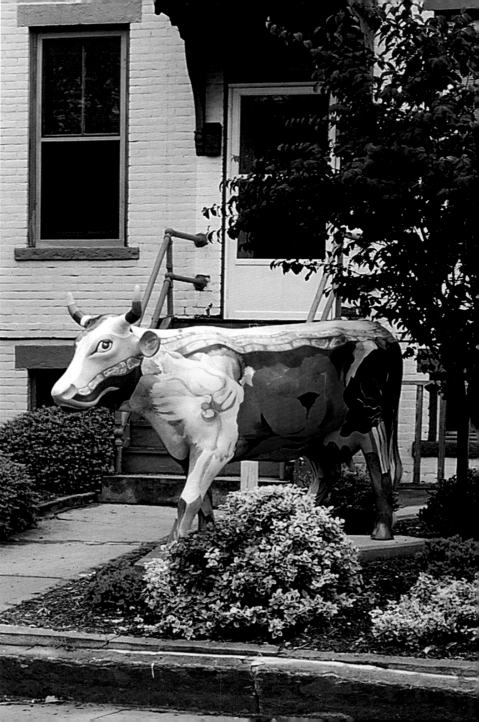

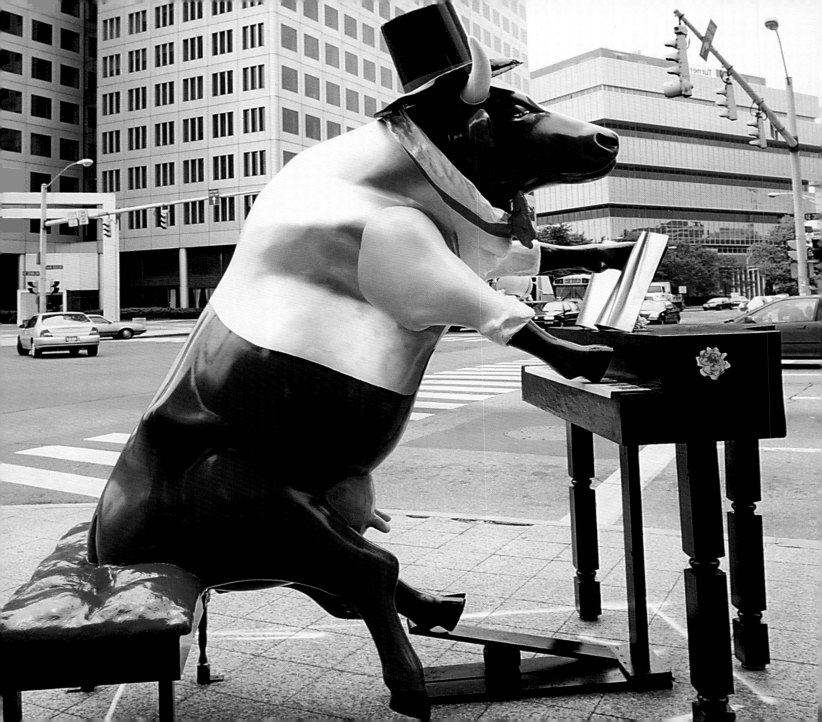

Piano Cow

ARTIST: **Beverly A. Branch**
PATRON: **Xerox Corporation**
LOCATION: **Rich Forum**
(at Atlantic Street and Tresser Boulevard)

Beverly Branch is an illustrator, designer, and portrait artist who works in a wide range of media, including gouache, watercolor, pastel, and acrylic. This is her first foray into scupture. *Piano Cow* greets visitors to the Stamford Center for the Arts.

"THE PURPLE COW"
by F. Gelett Burgess

I never saw a purple cow.
I hope I never see one.
But I can tell you anyhow,
I'd rather see than be one.

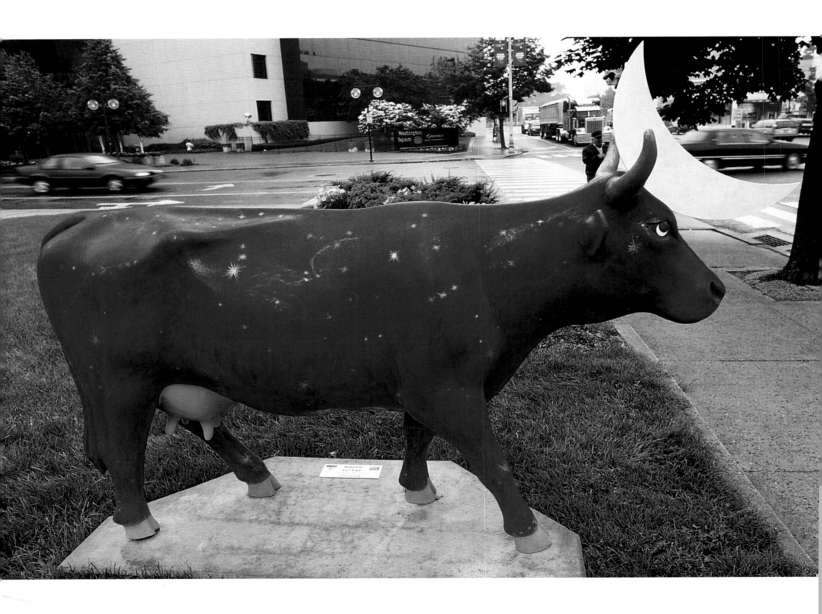

MOOONSTRUCK

(left)

ARTIST: **Diana D'Agostino**
PATRON: **Ashforth Family/ The Ashforth Company**
LOCATION: **Rippowam Park (at Washington Boulevard and Main Street)**

The cow jumped over the moon, as we all know from the beloved nursery rhyme. In D'Agostino's imagination, the moon retaliated. Here a glow-in-the-dark crescent moon has struck the cow and stuck to it.

Cowarium

(right)

ARTIST: **Bob Callahan**
PATRONS: **Stamford Chamber of Commerce, The Kids Our Future Trust Fund**
LOCATION: **733 Summer Street**

When graphic designer Bob Callahan learned that his cow was sponsored by The Kids Our Future Trust Fund, goldfish came to mind. He says that when he thought of children he thought of school, and when he thought of school he thought of fish. Of course, goldfish have been swimming in his brain for a long time. Callahan was on the design team that created the original packaging of the Pepperidge Farm Goldfish crackers in the 1960s.

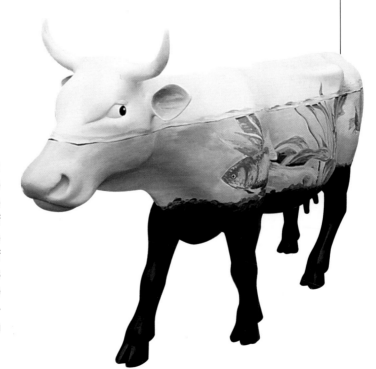

KEY COW FACTS
The average life span of a cow is 25 years.

Disco Cow

ARTIST: **Lisa Eisenman**
PATRON: **Crown Theatres—Majestic 6 & Landmark Square 9**
LOCATION: **Crown Majestic Theatre (at Summer Street)**

Lisa Eisenman created three cows for CowParade Stamford 2000. Her desire to work with mirrors inspired *Disco Cow,* which wears a shiny shirt made of hundreds of mirrors attached with epoxy. *Cowstruction* and *StamfHERD* (pages 26–27), were designed for Turner Construction, so Eisenman dressed one as a construction worker and covered the other with blueprints.

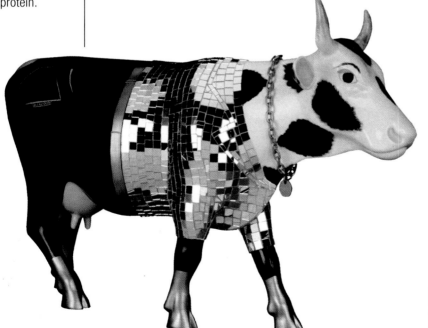

Cows can hear lower and higher frequencies better than humans do.

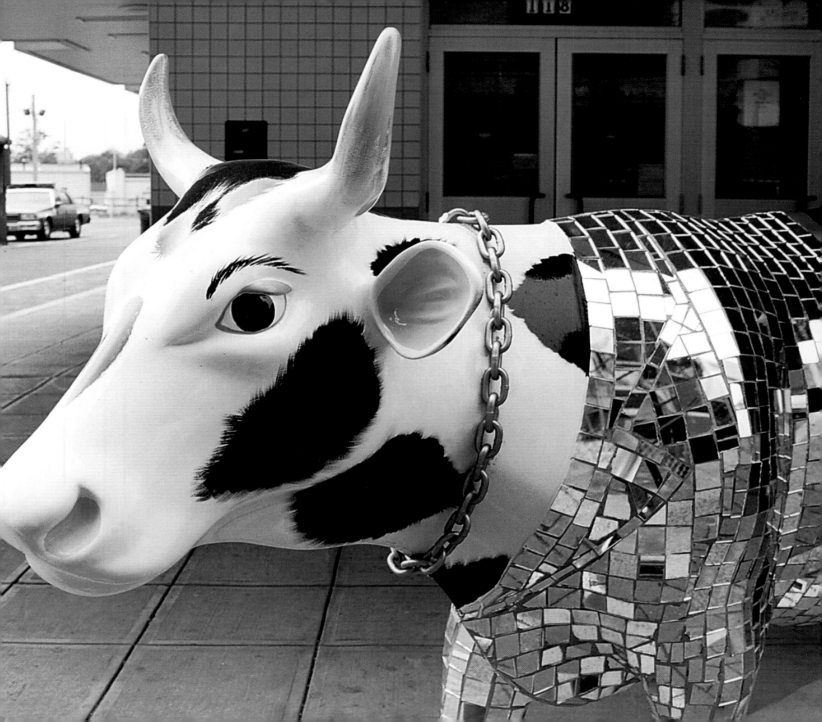

Cowstruction

(below)

ARTIST: **Lisa Eisenman**
PATRONS: **Turner Construction Company and ACM Consulting Corporation, AMX Contracting Corporation, CGM Acoustics, Inc., Cherry Hill Glass, Dupont Flooring Systems, IPC Information Systems, Inc., Johnson Electric Company, Inc., Mackenzie Service Company, Post Road Iron Works, Inc., SRI Fire Sprinkler Corporation, Tri-Star Building Corporation, W.R. Johnson Company, Inc.**
LOCATION: **Latham Park (at Bedford and Forrest Streets)**

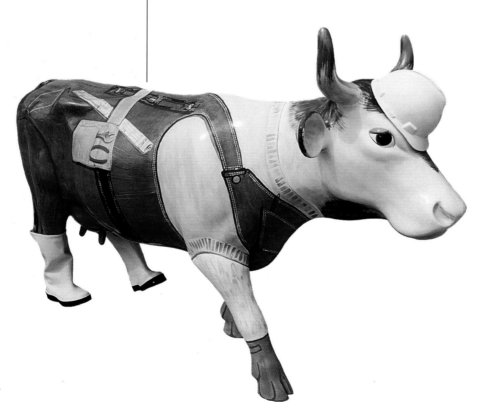

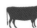

A COW GLOSSARY

- CALF: a young, sexually immature male or female cow
- COW: a mature female with at least one calf
- BULL: a mature male
- STEER: a neutered bull
- HEIFER: a young female cow that has never had a calf
- OXEN: male or female working cattle

StamfHERD

(right)

ARTIST: **Lisa Eisenman**
PATRONS: **Turner Construction Company and A&A Drywall & Acoustics, Inc., Belway Electrical Contracting, Capco Steel Corporation, Harry Grodsky & Sons, Inc., SRI Fire Sprinkler Corporation**
LOCATION: **Latham Park (at Bedford and Forrest Streets)**

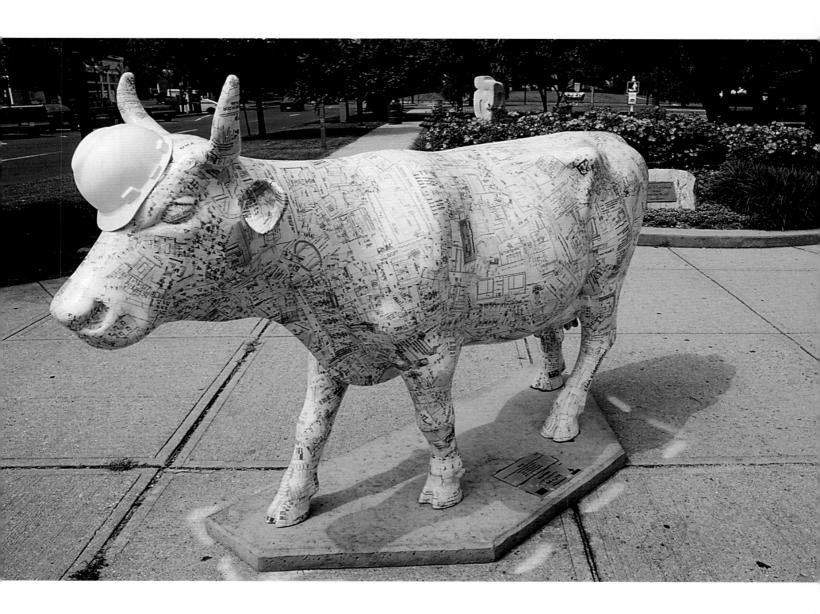

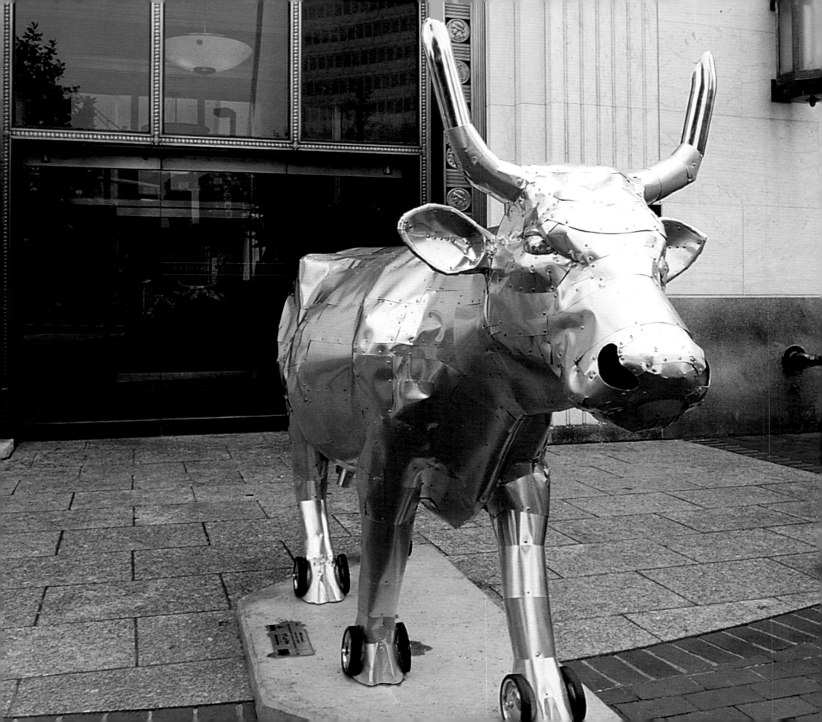

Canned Milk

ARTIST: **Don Ervin**
PATRON: **Clearview Investment Management Inc.**
LOCATION: **One Atlantic Street (at Broad Street)**

This is not the milk bottle you remember from the good old days. *Canned Milk* is a high-tech milk-making machine. Her surface is covered with pop riveted aluminum panels, her horns are augmented with exhaust pipes, and her hooves are attached to wheels. Ervin is a graphic designer and artist by profession and an industrial designer by training. This project combined all of his interests. "*Canned Milk*," he says, "took 2,000 pop rivets, 1,000 square feet of aluminum, and 2 boxes of Band-Aids."

RECORD-SETTING COWS

The Best Milk-Producing Cow Breed: Holstein, holds the record for milk production—67,914 pounds of milk in one year.

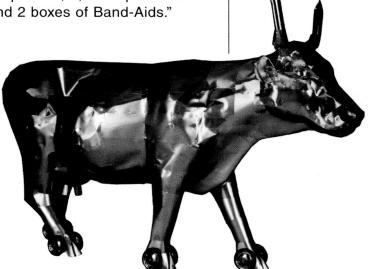

The Cow That Works— From Stamford, The City That Works

ARTISTS: **The Funke Twins
(Michael and Francine Funke)**
PATRON: **Stamford Marriott-Heyman Properties**
LOCATION: **Stamford Marriott Hotel**

The Cow That Works—a takeoff on Stamford's slogan, "The City That Works"— is a tribute to the city's commercial and civic success. Interlocking gears on the cow illustrate that Stamford is a well-oiled machine and ensure that it will roll smoothly into the future.

Detail from *The Cow that Works*

THE ORIGINAL COW TOWN
Boston's original street plan followed the cow paths that led to the Common, where cattle was pastured.

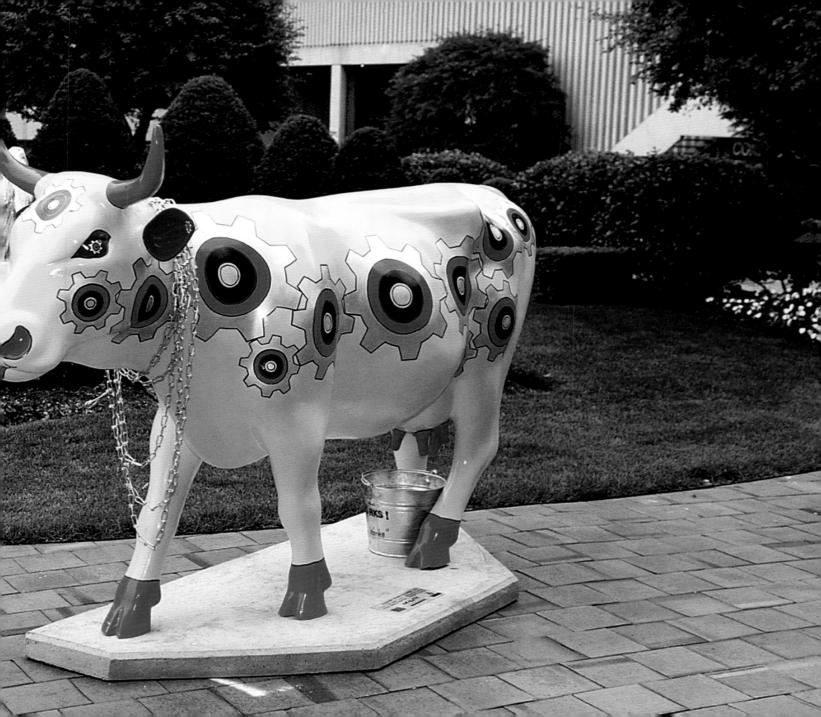

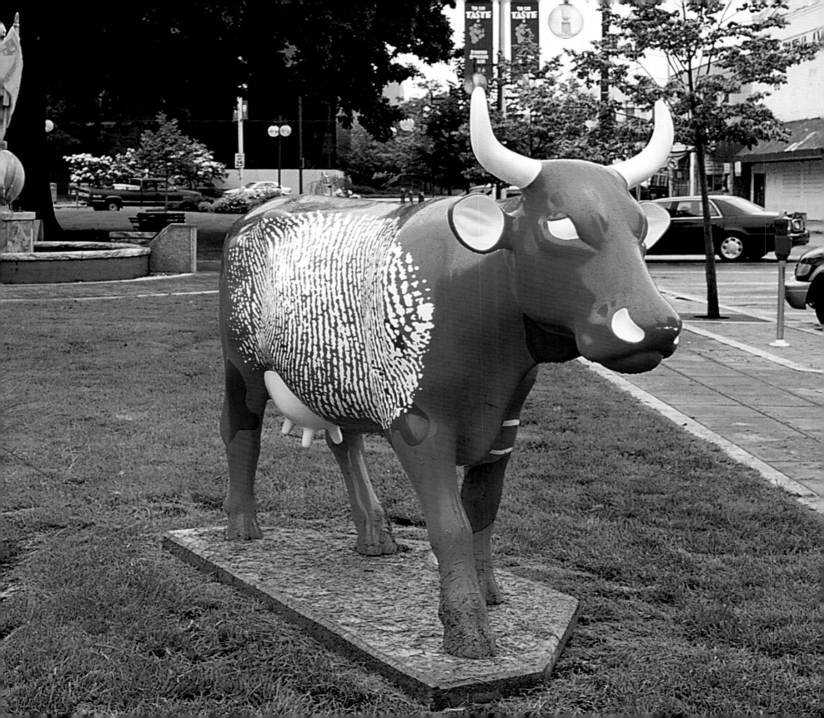

The Cow and I

(right)

Artist: **Sandy Garnett**
Patron: **Corcoran Jennison**
Location: **Columbus Park (at Main Street and West Park Place)**

KEY COW FACTS

It takes a gallon and a half of milk to make one gallon of ice cream.

Identity has always intrigued Sandy Garnett, who has been exploring the concept in the form of his fingerprint series of paintings. "Fingerprints," he says, "are a labyrinth of personality. They are the mark of individuality, which has become an important idea in this high-tech time."

The fingerprint on *Cow Print* is that of David Bowie's thumb. Garnett has been soliciting the fingerprints of people he admires for use in his series, and Bowie obliged. The piece is subtitled *David Bowie Contemplating Warhol's Cows*, in reference to the series of silk-screened cows created by Andy Warhol.

The Cow and I is painted with an enlargement of the artist's own fingerprint. He liked the idea of blowing the print up so large that it became abstract and ended up looking a bit like a zebra.

Both cows will remain in Stamford as part of a permanent collection.

Cow Print

(left)

Artist: **Sandy Garnett**
Patron: **Corcoran Jennison**
Location: **Columbus Park
(at Main Street and West Park Place)**

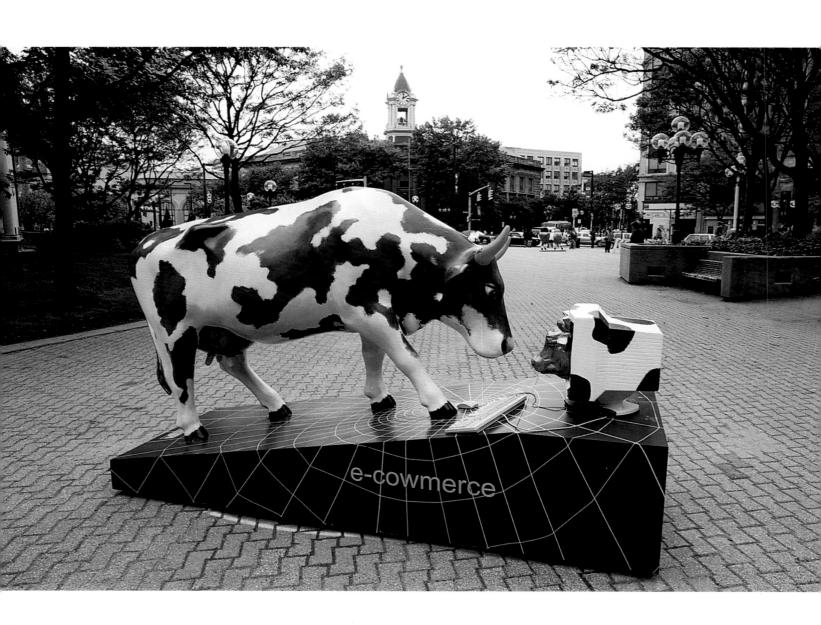

e-cowmerce

1 to 1 Mooo-keting

(left)

ARTIST: **Ivo J. Granata**
PATRON: **Peppers and Rogers Group**
LOCATION: **Veteran's Park (at Atlantic Street)**

Artist Ivo J. Granata developed the concept of the e-cowmerce cow and naturally, the one-to-one marketing company Peppers and Rogers Group fell in love with the design. The sponsor and artist then worked together on the final design for this interactive cyber-cow.

Twilight

(right)

ARTIST: **John DeMarco**
PATRON: **Reckson Associates Realty Corp.**
LOCATION: **Landmark Square (at Atlantic and Broad Streets)**

John DeMarco created *Twilight* as an after-school activity. The Stamford High School art teacher embraced the opportunity to paint on the life-size cow canvas, and its Landmark Square location is a great place for students to check out his work.

Beach Cowmber

ARTIST: **Elizabeth Hartstein**
PATRON: **Miller & Company PC**
LOCATION: **Cove Island Entrance**

Elizabeth Hartstein's 10-year-old son came up with the idea of a cow in a wet suit and named her *Beach Cowmber*. Hartstein loved the idea both because she has always lived by the beach and because it perfectly ties in with her work. A muralist and decorative painter, she owns a company called A Room with a Zoo, whose focus is children's murals.

KEY COW FACTS

Nobody on the planet eats more butter than New Zealanders, who consume 26 pounds per person each year. In the United States, however, butter consumption is spread pretty thin—only four pounds per person each year.

 HOLY COWS!: ANCIENT GREECE

Greek mythology tells the story of Io, a priestess of Hera who had the bad luck to attract the attention of Zeus. The king of gods started an affair with the young woman, and when his wife, Hera, got suspicious, Zeus changed Io into a dazzling white heifer. Hera saw through the ruse and sent a horsefly to torment Io. To escape the fly, the poor cow-girl ran the whole length of the Ionian coast, then swam the Bosphorus (which means "cow crossing") to Asia.

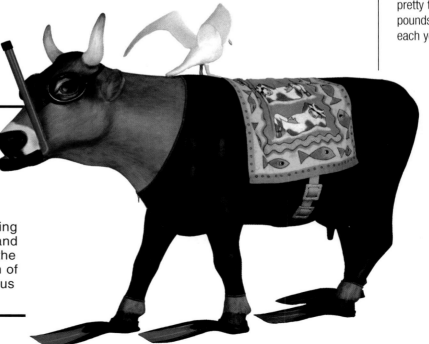

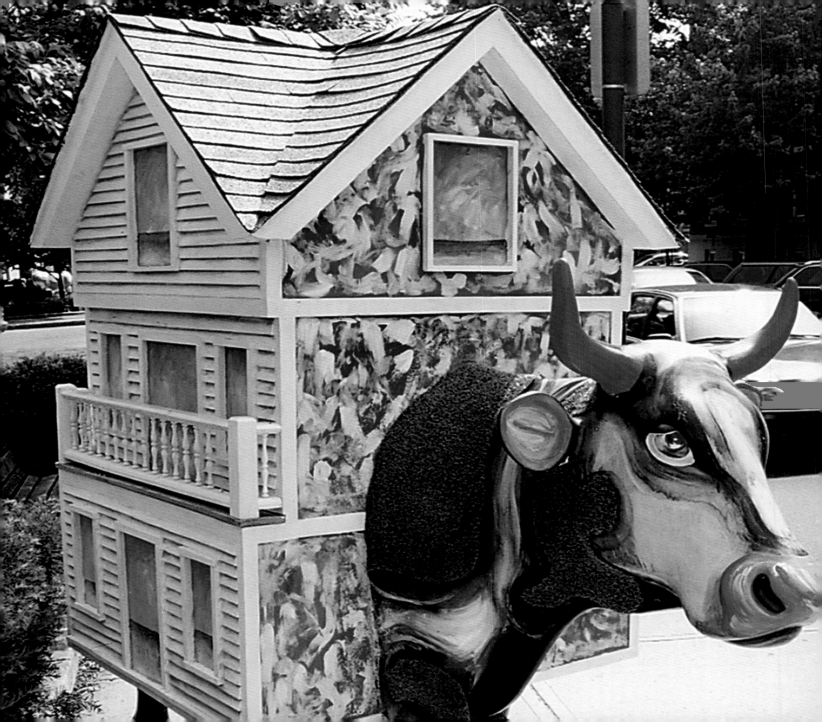

Cauhaus

(left)

ARTIST: **Bob Hepner**
PATRON: **Coldwell Banker Residential Brokerage**
LOCATION: **Bedford Street at Forrest Street**

Stamford real-estate company Coldwell Banker was happy to find *Cauhaus* a home in Stamford Downtown. In Bob Hepner's creation, you'll find all the comforts of home, right down to a well-manicured lawn.

Town & Country Cow

(right)

ARTIST: **Marjorie Tomchuk**
PATRON: **PanAmSat Corporation**
LOCATION: **St. John's Church**

Marjorie Tomchuk has been making her own paper and collecting handmade paper from around the world for many years. She thought that her cow would offer a good opportunity to showcase her lovely collection. Depicting scenes of rural Connecticut as well as downtown Stamford (buildings like One Landmark Square are clearly visible), *Town & Country Cow* represents the best the area has to offer.

COW LORE

If a cow lies down and does not graze, a storm is on its way.

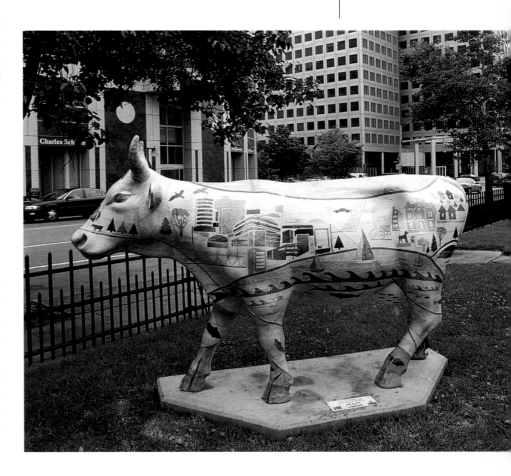

Holey Cow

(below)

ARTIST: **David Stein**
PATRON: **First County Bank**
LOCATION: **First County Bank (at Atlantic Street)**

Stamford high schooler David Stein is the son of Silvia Fernandez-Stein, the artist who created *Twinkle Toes*. The idea of *Holey Cow* appealed to him for the play on words as well as the technical challenge. He used a saw and lengths of PVC pipe to create holes big enough to pass an arm through in the Swiss cheese body of the cow.

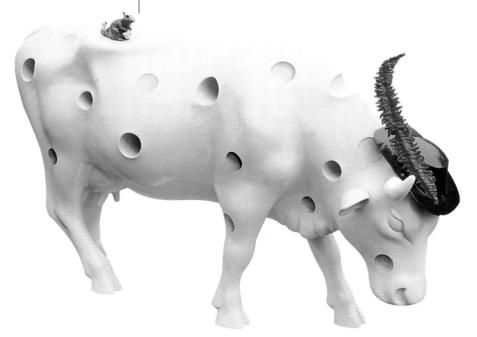

Elsbeth—The Dairy Fairy

(right)

ARTIST: **Robyn Isaacs**
PATRON: **Worldwide Clairol**
LOCATION: **Columbus Park**

Robyn Isaacs is an artist whose work focuses on ecology and the protection of animals. She had just finished a piece called *The Enchanted Forest,* which featured real animals such as bears, cheetahs, and wolves among imaginary creatures like elves and fairies, when she got the call to participate in CowParade. The phrase "dairy fairy" instantly rang in her ears, so *Elsbeth* was born.

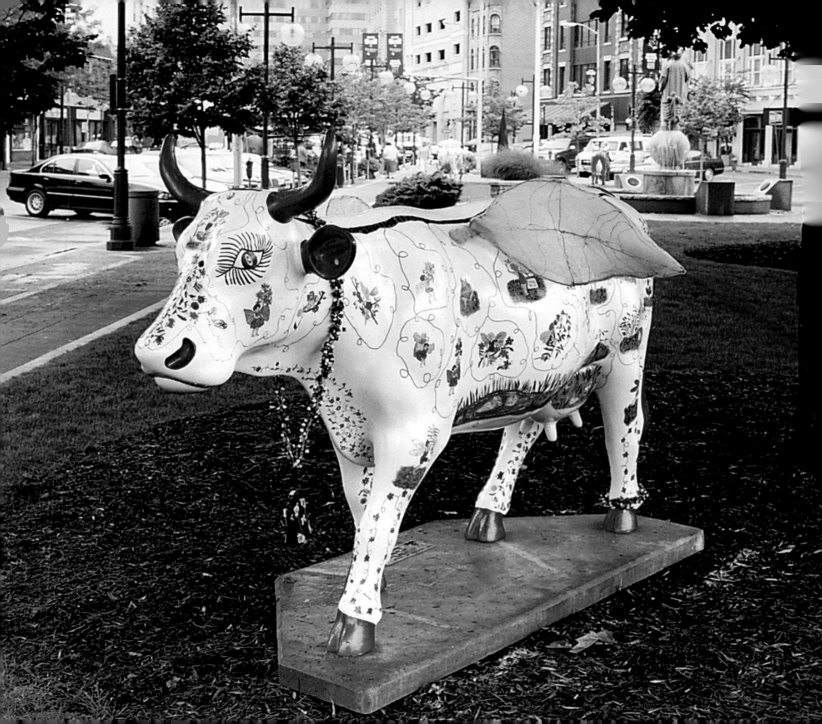

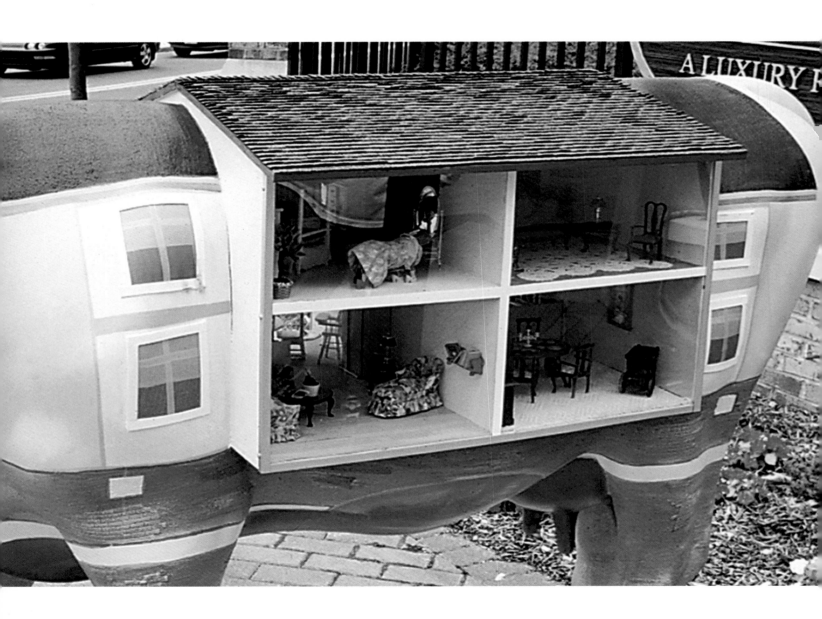

Luxury Cowmunity

ARTIST: **Daniel D. Kirsch**
PATRON: **Avalon Communities**
LOCATION: **Avalon Grove (at Broad Street and Greyrock Place)**

Created for real estate developer Avalon Communities, *Luxury Cowmunity* is designed to look like the Avalon property.

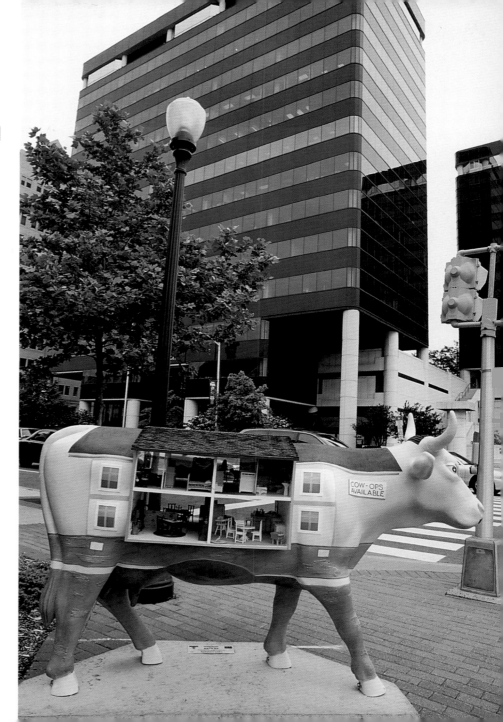

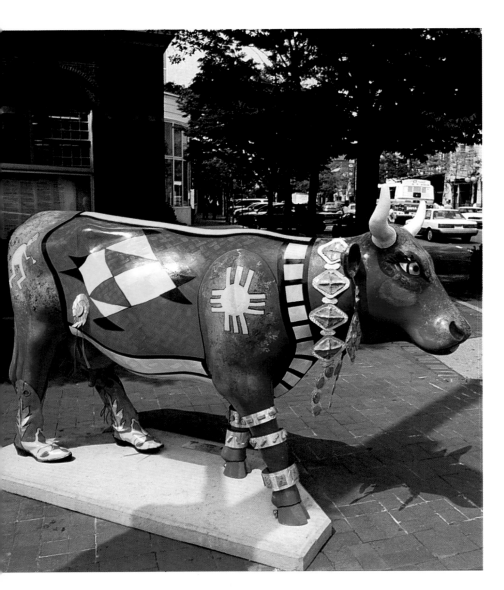

Turquoise Lady
(left)

ARTISTS: **Gordon Micunis and Jay Kobrin**
PATRON: **Juner Properties**
LOCATION: **Ferguson Library (at Bedford and Broad Streets)**

Turquoise Lady is inspired by Stamford's own turquoise lady, June Rosenthal, the realtor famous for her Santa Fe style. Micunis and Kobrin photographed some of Rosenthal's jewelry and clothing and then dressed the cow that her company sponsored in her fashion. *Turquoise Lady*, in addition to wearing lovely silver jewelry, also sports a tattoo. Rosenthal's husband's family were cattle dealers in Germany, so Micunis and Kobrin reproduced the family's brand on the "hide" of the cow.

Where's the Beef?
(right)

ARTIST: **Gordon Micunis**
PATRONS: **Bennett Steak & Fish House and Vitti Construction**
LOCATION: **Bennett's Restaurant (at Spring Street)**

Where's the Beef? was inspired by the Italian Renaissance surrealist Archimboldo, who re-created the body's anatomy with assorted realistically depicted fruits. *Where's the Beef?* proves that cows really are delicious.

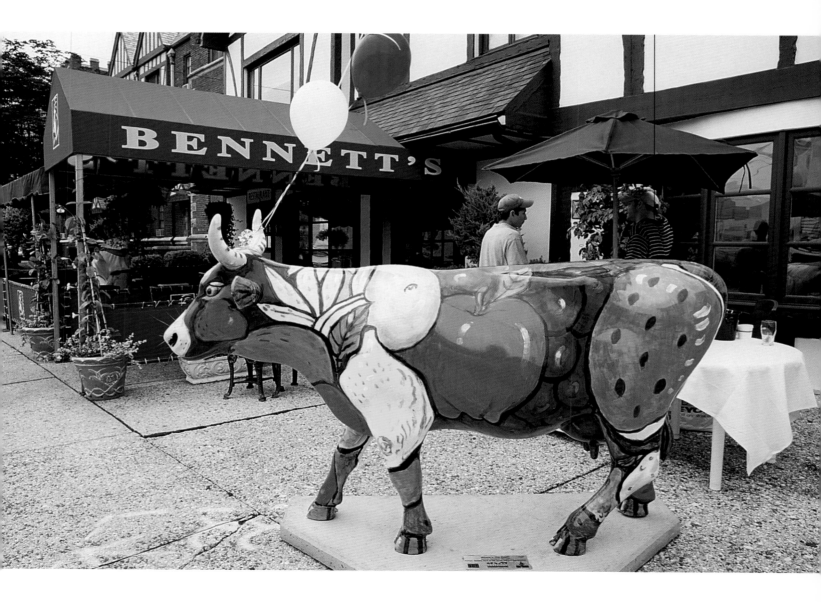

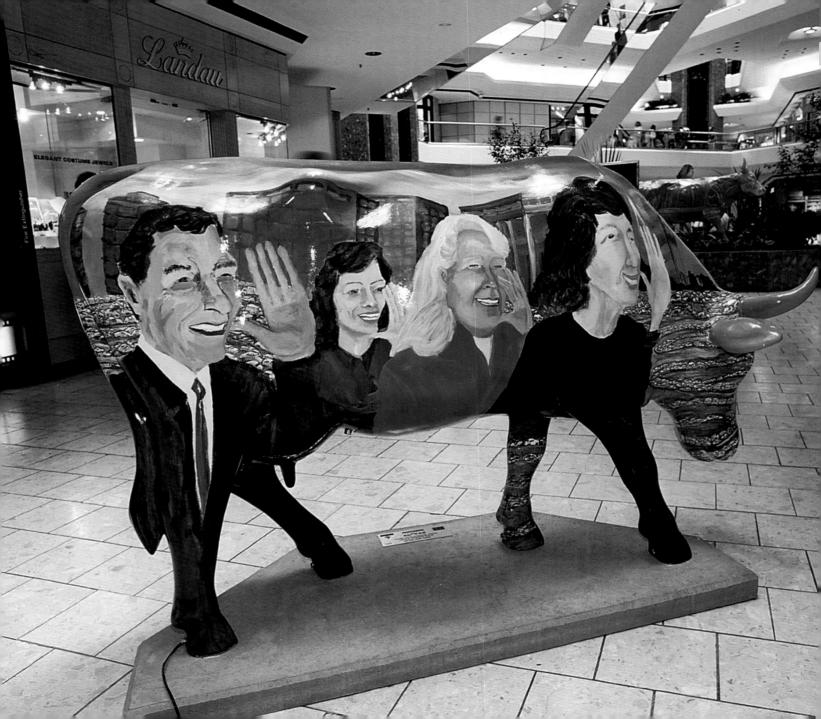

Have you Herd?

ARTIST: **Matthew Burcaw**
PATRON: **Stamford Town Center**
LOCATION: **Stamford Town Center**

Have you Herd? is a portrait of the city administrators who support arts in Stamford. The cow is interactive. When people walk by, a motion detector near the udder of the cow triggers a soundtrack that plays the voices of the people depicted on the cow telling corny cow jokes:

- Have you heard where cows go on dates?
 To the moovies.

- Have you heard what you get from a pampered cow?
 Spoiled milk.

- Have you heard why cows have no money?
 Because the farmers milk dry.

- Have you heard what you call a cow that just had a baby?
 Decalfinated.

- Have you heard about the cow with a tension headache?
 She's in a bad moood.

- Have you heard how cows greet each other?
 They give each other a milkshake.

- Have you heard about the forgetful cow?
 Everything goes in one ear and out the udder.

KEY COW FACTS

There are 92 different breeds of cows in the world.

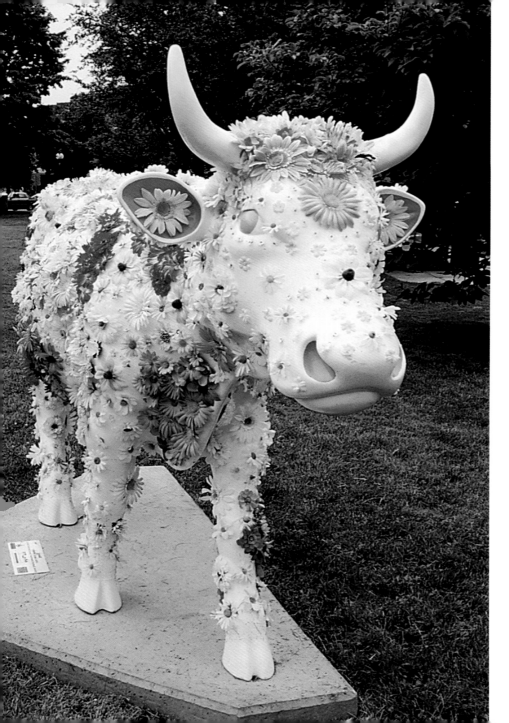

Daisy
(left)

ARTIST: **Joan B. Wheeler**
PATRON: **Stamford Downtown Special Services District**
LOCATION: **Latham Park (corner of Prospect and Walton Place)**

Daisy commemorates the flowers that adorn the downtown throughout spring and summer.

Miracles—The Special Delivery Cow
(right)

ARTIST: **Lina Morielli**
PATRON: **Stamford Health System—The Stamford Hospital Neonatal Unit**
LOCATION: **Corner of Main and Summer Streets**

Miracles was designed for its sponsor, the neonatal unit of The Stamford Hospital. With the help of artist Lina Morielli, babies who had been cared for in the unit and who are now growing and thriving painted the cow. The babies lent their hands and feet to print the cow: girls' handprints and footprints appear in pink; boys' appear in blue. The proceeds from the auction of *Miracles* will return to the neonatal unit so that more boys and girls will benefit from its services in years to come.

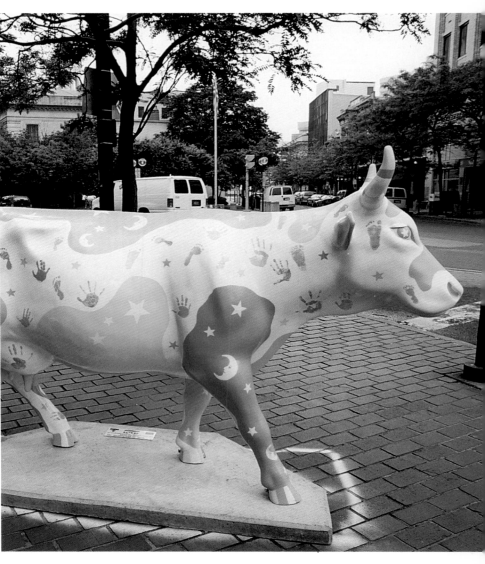

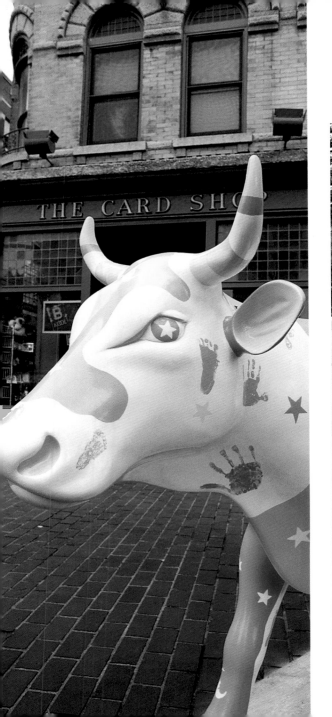

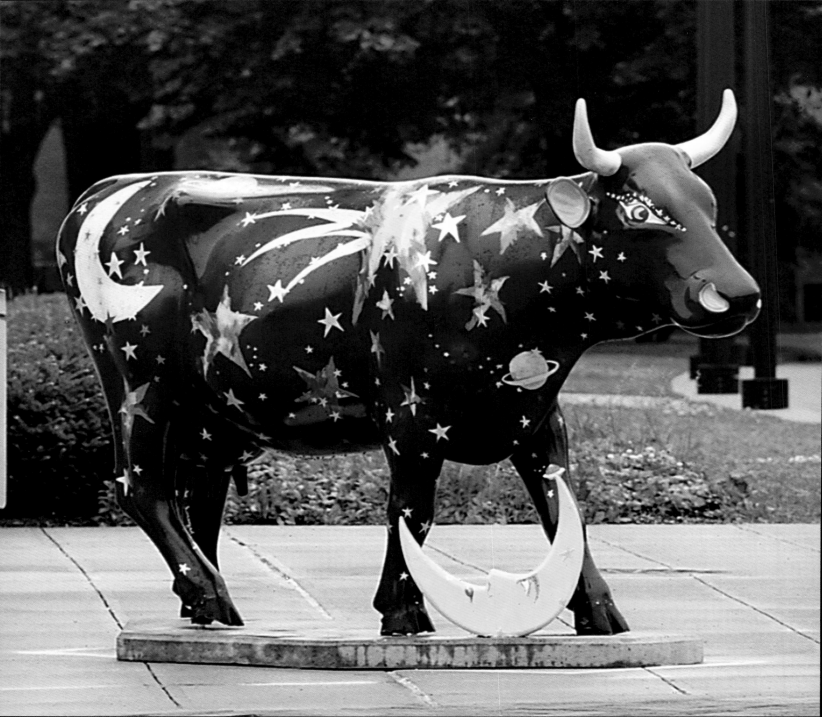

Hugh Heffer

(below)

ARTIST: **Derrick Quarles**
PATRONS: **Crown Theatres—Majestic 6 & Landmark Square 9, Coastal Fairfield County Convention & Visitors Bureau**
LOCATION: **Crown Landmark Square (at Broad Street)**

This playboy is the only evidence of beef-cake in the Stamford CowParade.

Moo Beam, The Cow that Jumped Over The Moon

(above and left)

ARTIST: **Jan Raymond**
PATRON: **Citibank F.S.B.**
LOCATION: **UCONN (at Washington and Broad Streets)**

The Cow that Jumped Over the Moon wears track shoes to aid in her ambitious endeavor.

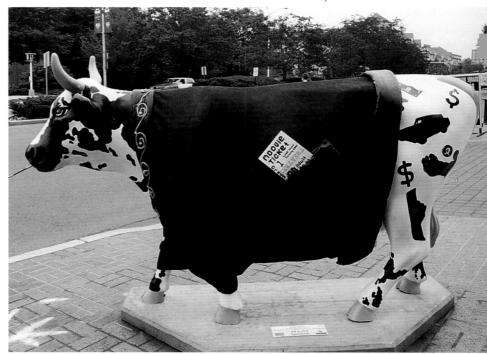

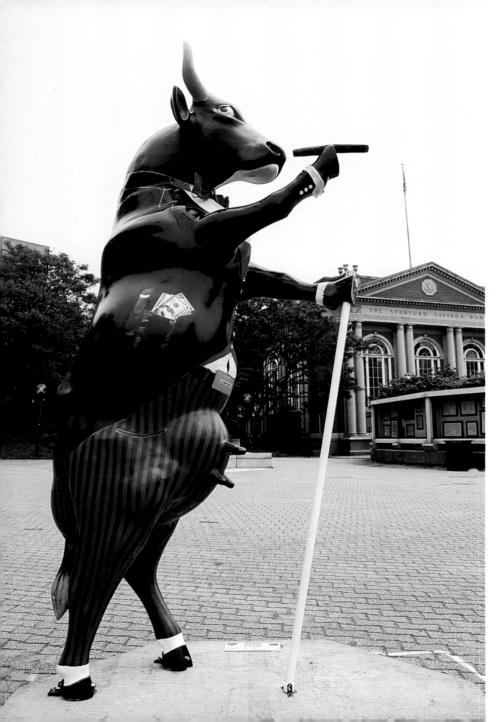

J. Cash Cow IV

Artists: **Peter J. Cornell with Peter J. Cornell IV, Christina P. Cornell, and Denice Suriano**
Patron: **Taurus Advisory Group**
Location: **Veteran's Park (at Atlantic Street)**

Unlike *Bum Steer*, *J. Cash Cow IV* is living high on the hog. Thriving in the bull market, his fortune is rumored to have come from cowmodities.

Bum Steer

ARTIST: **Jan Raymond**
PATRON: **Taurus Advisory Group**
LOCATION: **Veteran's Park (at Atlantic Street)**

Down on his luck, *Bum Steer* is a hobovine.

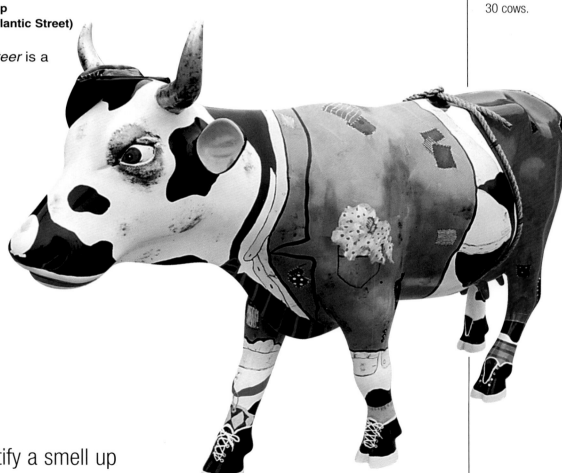

Cows can identify a smell up to five miles away.

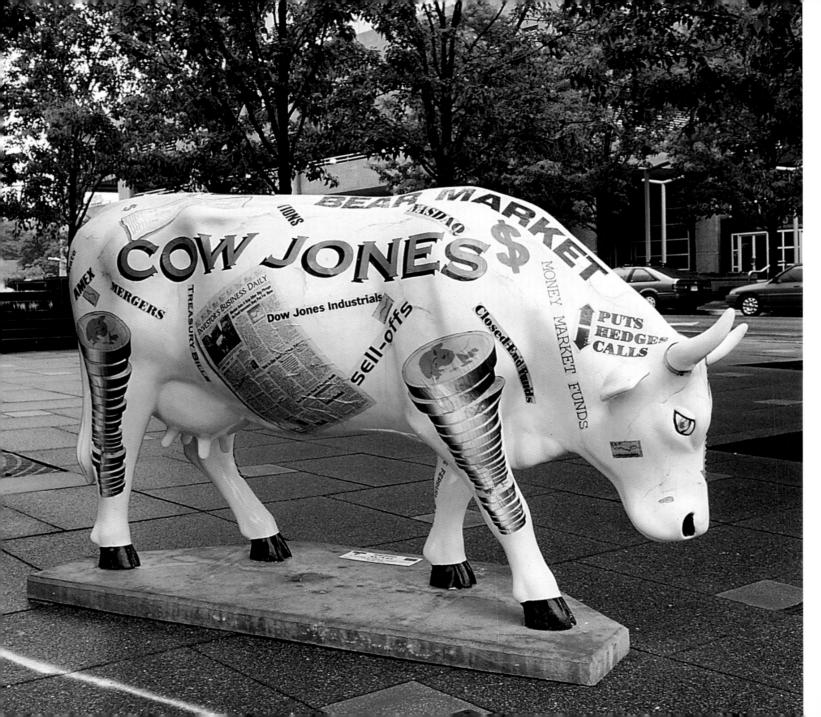

Cow Jones

ARTIST: **Nanette Ferreri**
PATRONS: **Deborah and Robert S. Salomon, Jr.**
LOCATION: **Stamford Towers (at Washington Boulevard)**

Inspired by the enduring bull market, *Cow Jones* charges into the future bringing Stamford with her.

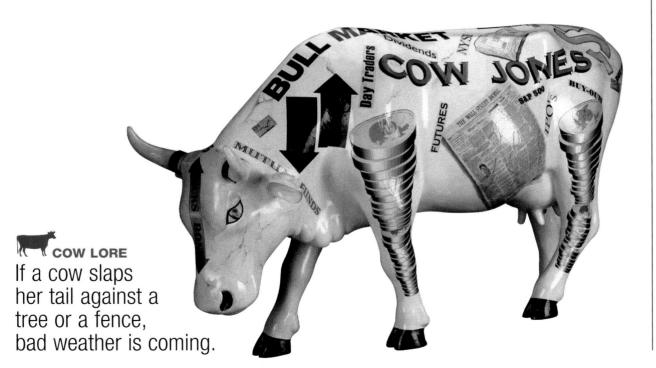

COW LORE

If a cow slaps her tail against a tree or a fence, bad weather is coming.

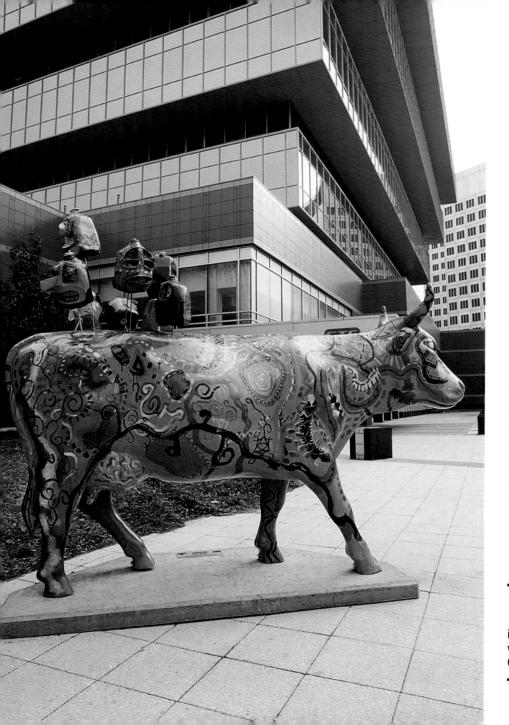

Magical Cow of the Universe

ARTISTS: **Janet Slom and Ms. Homa's Eighth Grade class, the Rippowam School**
PATRON: **Purdue Pharma**
LOCATION: **Purdue Pharma (at Tresser Boulevard)**

As a professional studio artist, teacher, and philosopher, Janet Slom aims to reach as many children as possible. She explains that "through the creative process, children learn to discover their uniqueness and powerful voices. The *Magical Cow of the Universe* represents the children's creative interpretation of self. The masks reveal each child's individual identity, intuition, and vulnerabilities. The vibrant colors and energetic patterns reflects their spontaneity and playfulness." Fifty children helped to create the *Magical Cow of the Universe*.

COW-QUISTADORS

The first cows—500 of them—arrived in what is now the United States in 1540 with the Spanish explorer Francisco de Coronado.

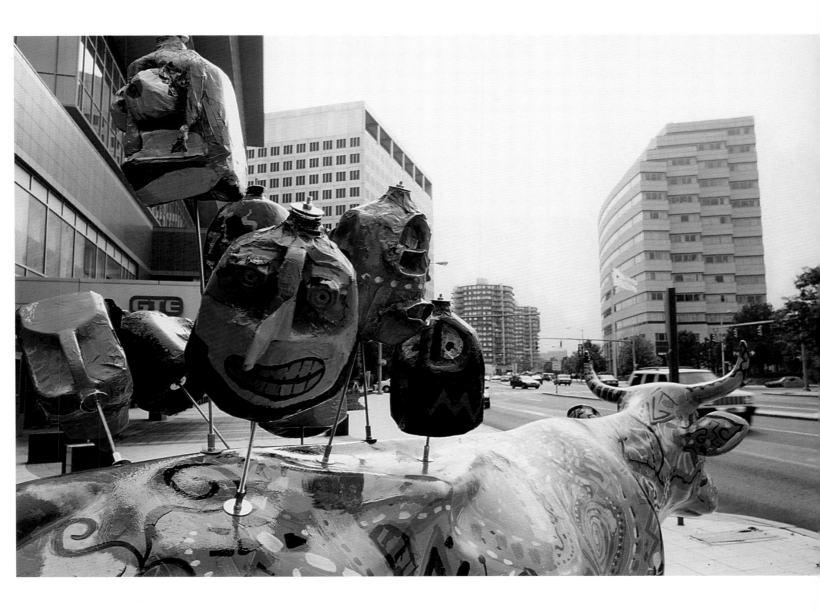

Cow...ch

ARTIST: **Matthew Burcaw**
PATRON: **Stamford Town Center**
LOCATION: **Stamford Town Center**

Matthew Burcaw is a painter, but when he wanted to create a cow that was truly interactive, he came up with *Cow...ch.* Covered in a fuzzy cow-pattern fabric, *Cow...ch* has become a favorite place for children to take a break from shopping at the Stamford Town Center. The cow's popularity means that she will have to be reupholstered several times throughout the summer.

DID YOU KNOW?

On average, a Holstein will be a good milk producer for three to four years.

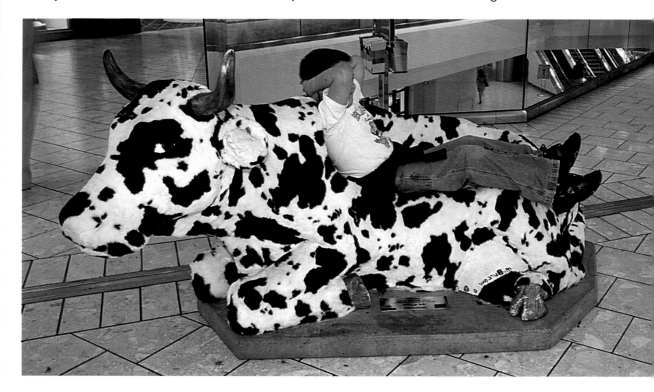

Zee Cow

ARTIST: **Donald Morrison**
PATRON: **Purdue Pharma**
LOCATION: **Corner of Tresser Boulevard and
Canal Street**

It is easy to look at *Zee Cow* and think
everything is in order. But then one walks
away marveling at what a fat zebra that
was. This is a cow trapped in a zebra's
body—or is it the reverse? In either case,
the usual black spots that appear on
Holstein cows have been transformed into
the graceful lines of a zebra.

HOLSTEIN HARDWARE

Gateway, the popular computer
manufacturer, started on founder Ted Waitt's
family cattle farm in Iowa in 1985. In honor
of the cows that were right outside the door,
Waitt had all the packaging associated
with the company sport a Holstein pattern.
The company's first national magazine ad
was shot on the farm with some of the herd
in 1988. Although Gateway has pretty much
put the cow ads out to pasture, it has kept
the spots on the boxes to remind folks of
the company's Midwestern roots and the
values on which it was established: hard
work, honesty, friendliness, and quality.

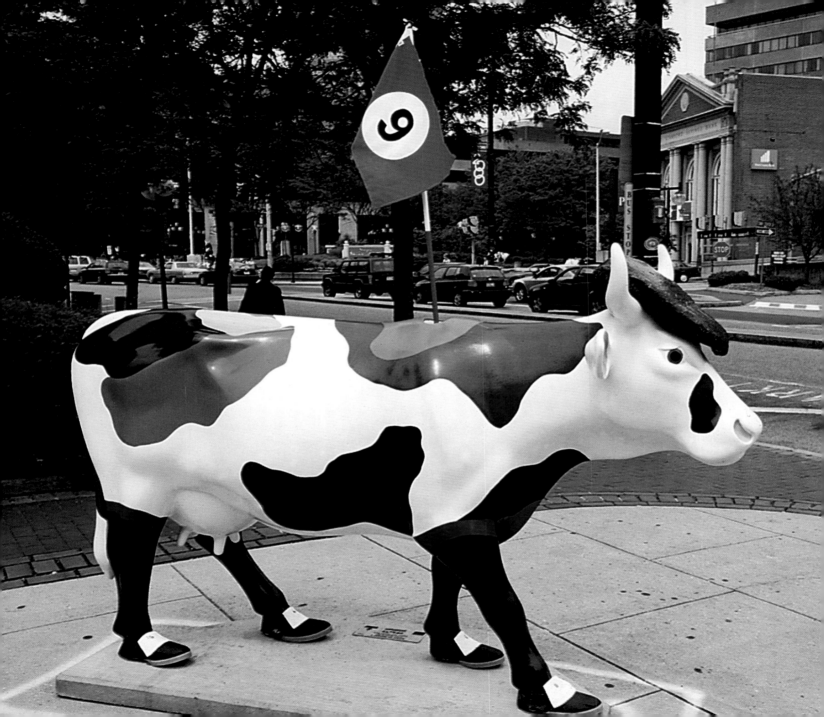

Bovine on Number 9
(left)

ARTIST: **Susan H. Ryf**
PATRON: **First County Bank**
LOCATION: **Old Town Hall (at Bank and Atlantic Streets)**

The gentle slopes and curves of the cow's body reminded the artist of the rolling hills of a golf course and inspired her to create *Bovine on Number 9*.

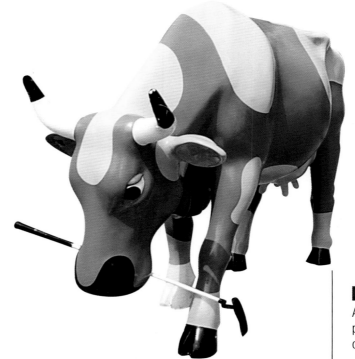

KEY COW FACTS

A cow eats about 100 pounds of grass each day.

The Golfing Cow
(right)

ARTIST: **Adam Niklewicz**
PATRON: **Mario Lodato Real Estate**
LOCATION: **Bedford Street at Spring Street**

On *Golfing Cow*, the spots of the typical Holstein cow are replaced by the sand traps of a golf course. "The patterns struck me as similar," explains Niklewicz, "and of course there are many places to play golf in Connecticut so the theme seemed appropriate." Niklewicz himself doesn't play, however, and that led to problems in the production of the cow. "When my neighbor, who does play golf, saw the cow standing over a green with a driver in its mouth, she explained to me that the cow was using the wrong club. I had to saw the driver off and replace it with a putter, which was not easy to do."

Electric Blue Moo
(below)

ARTIST: **Barbara S. Hotz**
PATRON: **The Thomson Corporation**
LOCATION: **Metro Center, One Station Place**

Artist Barbara Hotz was inspired by the work of Jackson Pollock when she created *Electric Blue Moo.* Her use of bold color and angular patterns on an oversized canvas are reminiscent of the famous artist's styles.

COWCAM!

From Virtual On-Ramp's home office in Alloway, New Jersey, comes CowCam, your window into the mysterious life of cows (during daylight hours, that is—what the cows do when the lights go out is their own business).

The CowCam is pointed at a bona fide cow pasture in southern New Jersey where actual cows actually graze. The picture is updated every five minutes between sunrise and sunset.

If you don't see any cows on your monitor, hit Reload. If you still don't see any cows, they have wandered out of the camera frame, in which case you should come back later.

Log on to CowCam at: www.accsyst.com/cow.html.

Baryshnicow
(right)

ARTIST: **Zora**
PATRON: **F. D. Rich**
LOCATION: **Landmark Square (at Atlantic and Broad Streets)**

For the artist Zora, a theatrical scenic painter, the cow is a small canvas. *Baryshnicow* beautifully combines her love of art, dance, and theater.

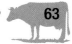

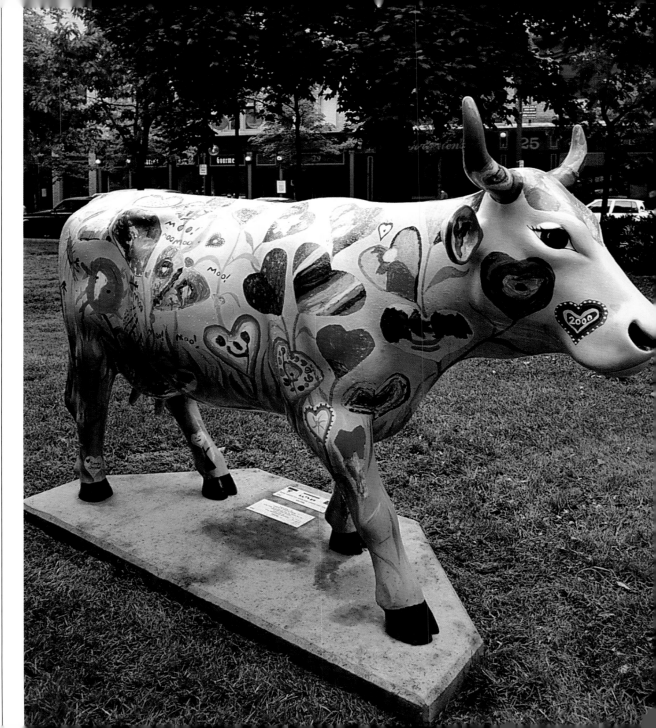

Harriet

(left)

ARTISTS: **Hart School's First Grade and Christen Napier**
PATRONS: **Archstone Communities Trust: Mr. Scott Shaull. Summer High Associates: Mr. Clay Fowler, Mr. Steve Hoffman, and Mr. Milton Mann. Perkins Eastman & Partners: Mr. L. Brad Perkins.**
LOCATION: **Heritage Park (at Main Street)**

Hart School First Graders in Mrs. Mullins's class used their cow to complete their study of cows in the United States. The students worked with artist Christen Napier to create a cow that's got a lot of heart.

Cowoperation for Education

(right)

ARTIST: **Zora**
PATRONS: **GE Capital and The K2C Collaborators**
LOCATION: **UCONN (at Broad Street)**

Zora's design for a cow with an education theme was embraced by GE Capital's K2C Collaborators. The K2C (Kids to College) project is a corporate and community project to support children throughout their education, beginning in elementary school.

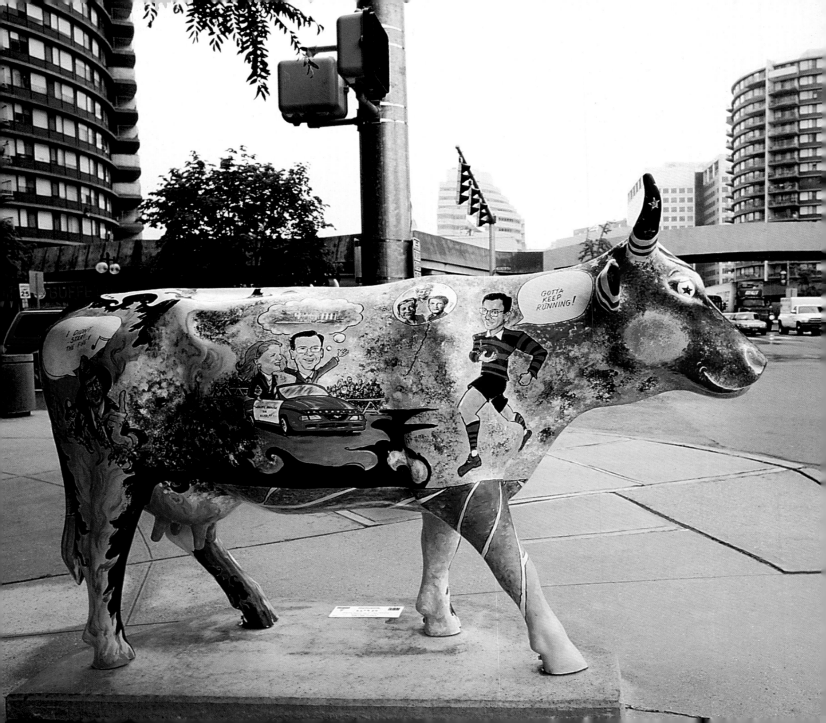

Mayor Moolloy

Artist: **John Stevens**
Patron: **Friends of Mayor Malloy**
Location: **Government Center (at Washington and Tresser Boulevards)**

Mayor Moolloy embraced the idea of CowParade as a means of capturing the imagination of children of all ages. The cow consists of a series of caricatures that depict aspects of Mayor Malloy's terms in office. In the detail below Mayor and Cathy Malloy lead the Stamford Helium Balloon Parade. At right, Major Malloy rides a bucking bovine.

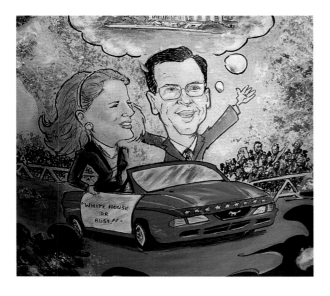

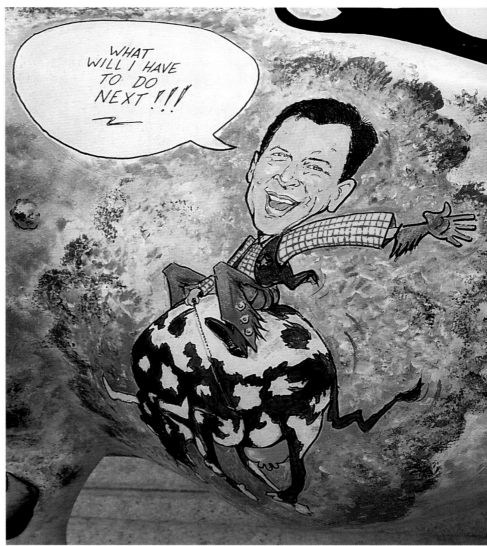

Betty Boop smiles up from *Comical Cow*

Comical Cow

ARTISTS: **Acclaimed Cartoonists: Mort Walker (*Beetle Bailey*), Brain and Greg Walker (*Hi and Lois*), John Cullen Murphy (*Prince Valiant*), Jerry Dumas (*Sam and Silo*), Mel Casson (*Redeye*), and Bill Janocha and Neal Walker**
PATRON: **The Advocate/Greenwich Time**
LOCATION: **Washington Boulevard at Tresser Boulevard**

Renowned cartoonist Mort Walker, creator of *Beetle Bailey*, and his associates created this comical cow, a sure favorite of anyone addicted to the "funnies."

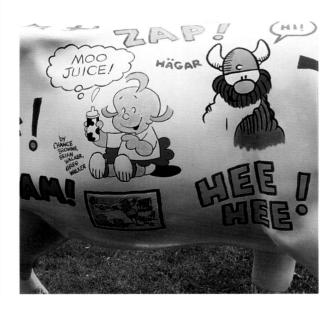

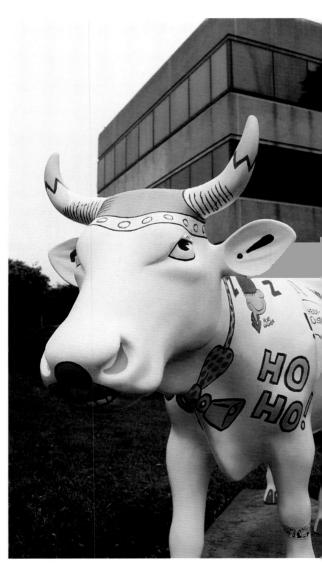

Mama Cow with Carriage

ARTISTS: **Edward Fountain and Ellen Hopkins Fountain**
PATRONS: **Baby & Toy Superstore and Hometown Marketing**
LOCATION: **Baby & Toy Superstore (at Forrest Street)**

Because she was being sponsored by a baby store, Ellen Hopkins Fountain decided to make her cow a mom. *Mama Cow* is a very chic mother who wears capri pants with a lace border and a flowery blouse inspired by upholstery fabric. Unlike the many Holsteins in the show, *Mama Cow* is a brown cow.

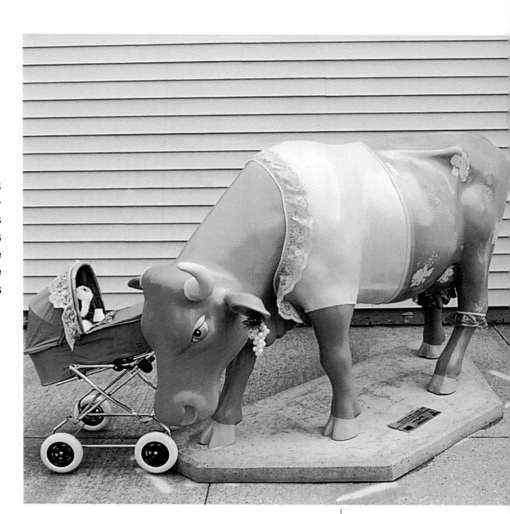

China Cow

ARTIST: **Angela Loeffel Burns**
PATRON: **Clearview Investment Management Inc.**
LOCATION: **One Atlantic Street (at Broad Street)**

When Burns heard that Stamford was launching an art show of cows, she immediately remembered a creamer shaped like a cow that she'd had as a child. Creamers made her think of china, so she decided to make her cow look as though it were made of china. The marking on the cow is the popular chrysanthemum pattern that originated in China but has become beloved around the world.

It took 13 coats of paint to finish the cow, but Burns was up to the task. She earned her B.F.A. at the University of New Mexico, where she studied under Georgia O'Keeffe, among others.

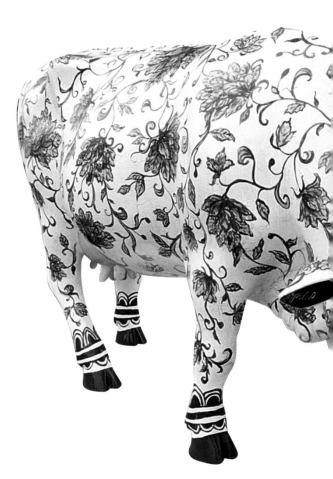

Bumble Bee Cow

ARTISTS: **Roger Huyssen, Kit Campbell, Steve Garbett**
PATRONS: **North Castle Partners Advertising and Silverman Realty Group**
LOCATION: **Heritage Park (at Bank Street)**

The artists and designers at the advertising firm of North Castle Partners created the whimsical *Bumble Bee Cow* for the park in front of their office.

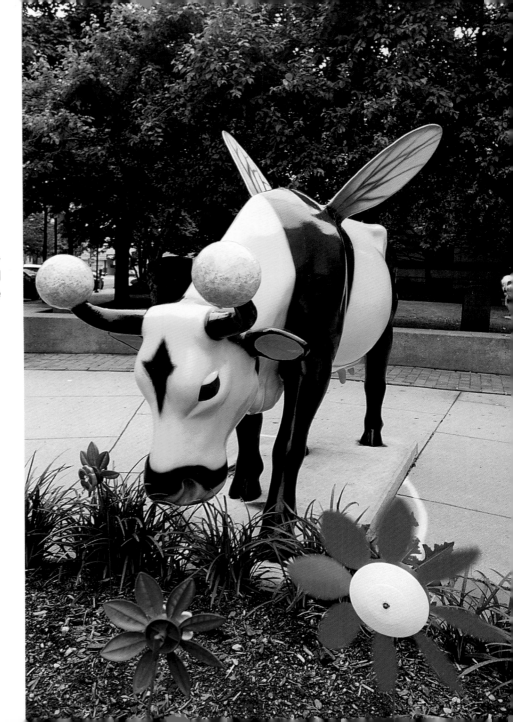

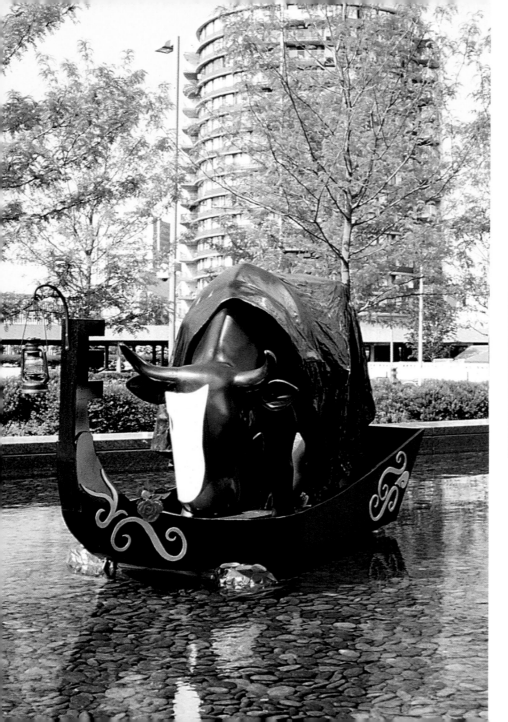

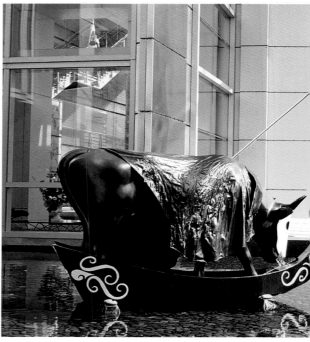

🐄 HOLY COWS!: IRELAND

The 5th-century Irish nun St. Brigid of Kildare is said to have been a milkmaid before she entered the convent. According to legend, the small herd of cows she kept at Kildare produced a whole lake of milk every day. In Ireland, St. Brigid is venerated as the patron saint of dairy farmers.

Bovine of the Opera
(left)

ARTISTS: **Michele Futernick, Aniuska Mohan, Patti Tower**
PATRON: **UBS Warburg**
LOCATION: **UBS Warburg fountain (at Washington Boulevard)**

Bovine of the Opera will not be mistaken for anyone else, even wearing that mask. Unlike her phantom counterpart, this bovine does not paddle around subterranean canals; she glides around the fountain at the UBS Warburg building.

DID YOU KNOW?
Holstein heifers can be bred at 13 months.

Monsieur Vache
(right)

ARTIST: **Jennifer Giannitti**
PATRON: **Grade A ShopRite**
LOCATION: **Landmark Square (at Atlantic Street)**

When Stamford High student Jennifer Giannitti got the application for CowParade and saw the word "artist," she instantly pictured the painters of Paris who work on the streets of the city. *Monsieur Vache*, however, is not painting Montmartre or the Eiffel Tower—he's painting Stamford's own Landmark Square.

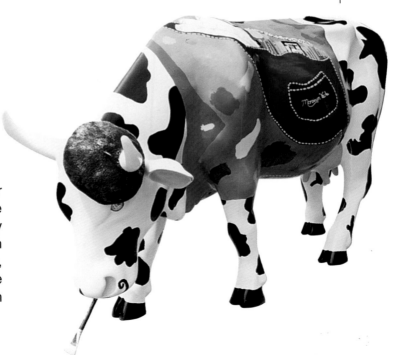

DID YOU KNOW?

A Holstein's spots are like snowflakes: no two Holsteins have exactly the same pattern.

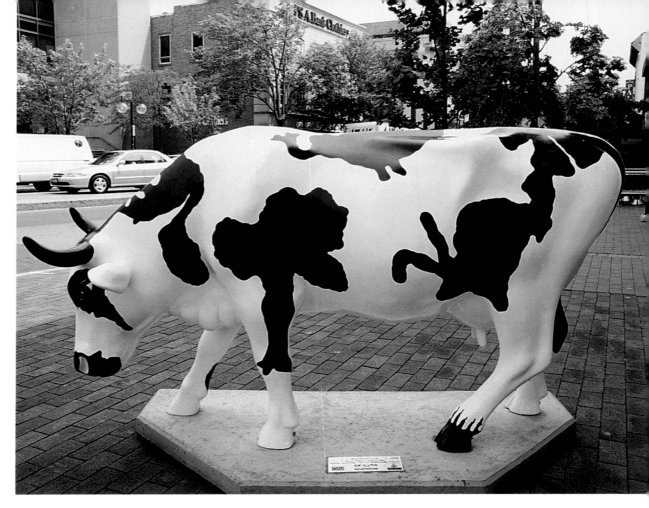

Rorschach Cow

ARTIST: **Mary Jo McGonagle**
PATRON: **Clearview Investment Management Inc.**
LOCATION: **One Atlantic Street (at Broad Street)**

From a distance this cow would appear to be an ordinary Holstein. But a closer look reveals that the inky spots are images of real things—including an airplane, ice-cream cone, tree, rabbit, squirrel, butterfly, snake, flower, and birthday cake.

You Can't Have a Parade Without a CloWn

Artist: **Marcele A. Mitscherlich**
Patron: **Avalon Communities**
Location: **Avalon Corners (at Washington Boulevard)**

Mitscherlich felt strongly about creating a cow that was beautiful and that could be appreciated from a distance. Rather than just putting a painting on a cow, she wanted to incorporate the shape of the cow into her design, and her clown cow has enabled her to do just that. The body of the cow is wearing a painted clown suit that has an antique feel to it. The colors are not the bright, childish primaries one might expect, but the complex and slightly faded colors of a circus clown of yore. The ruffle around the neck is made of fiberglass; the shoes are a real pair of clown sneakers. Mitscherlich had no trouble tracking down all the materials she needed to create the cow. As a member of the United Scenic Artists Union, she creates sets for television shows from *Sesame Street* to *Saturday Night Live* and films from *You've Got Mail* to *Sleepy Hollow*.

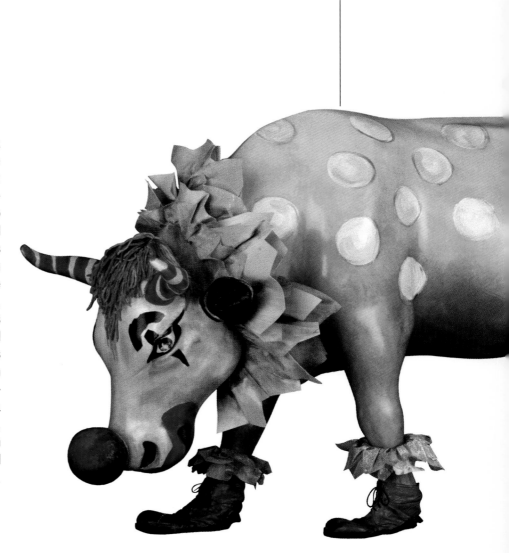

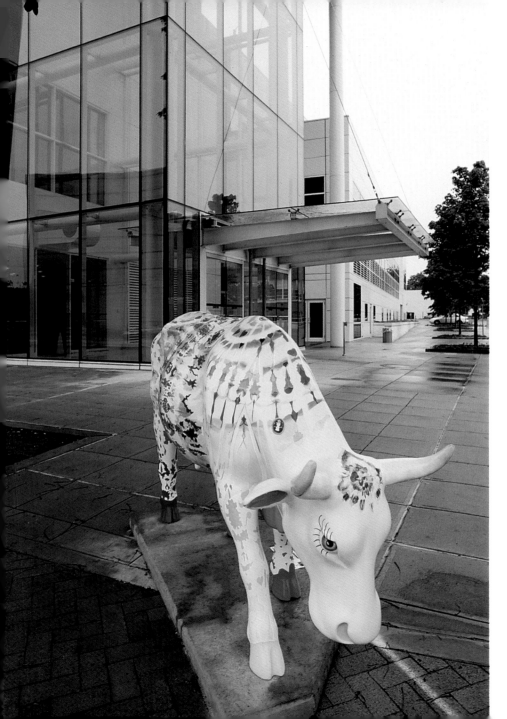

Udderly Groovy Lady Belle Bennett

ARTISTS: **L. E. Murray and 77 other painters, including patients, families, and staff of the Bennett Cancer Center**
PATRON: **Carl & Dorothy Bennett Cancer Center—Stamford Health System**
LOCATION: **UCONN (at Broad Street)**

Seventy-eight patients, family members, staff, and volunteers of the Bennett Cancer Center joined forces to create this colorful tie-dyed cow. Art has been an important therapeutic outlet for patients at the center since 1993, when the center's Expression Through Art Program was established.

Udderly Groovy Lady Belle Bennett was a very special project, instilling in all the participants a sense of camaraderie, cooperation, and accomplishment. Although she did not wear a white coat, *Lady Bennett* made rounds just like a doctor to visit the patients who worked on her.

 Cows can see color.

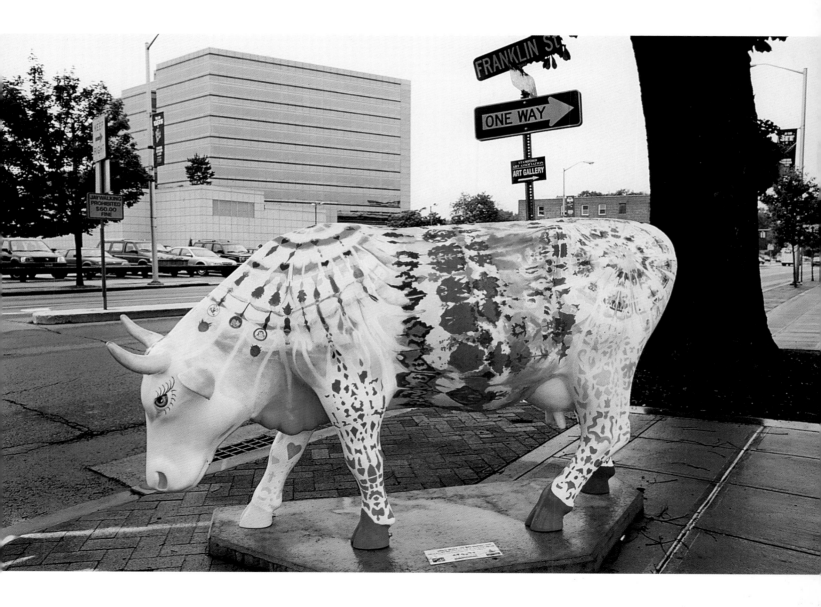

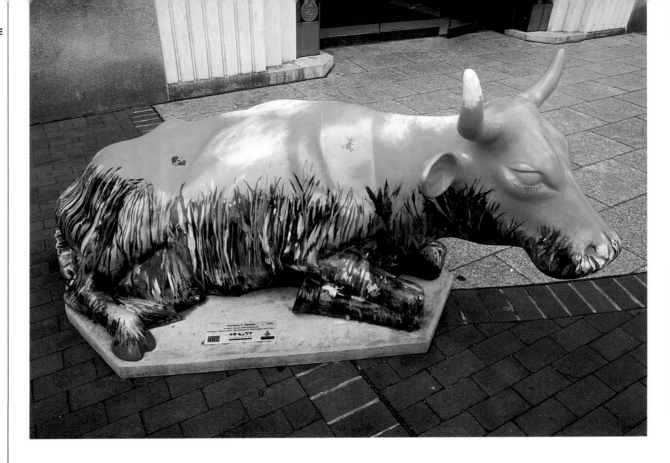

Pasture I. Zation

ARTIST: **Leon Chmielewski**
PATRON: **Clearview Investment Management Inc.**
LOCATION: **One Atlantic Street (at Broad Street)**

The idea for *Pasture I. Zation* came from a painting of a field of grasshoppers Chmielewski had made years ago. When he thought of painting a cow, he remembered it and decided to make reference to it here. This cow appears to be sitting in a field of the artist's long, painterly grass, daydreaming as wispy clouds blow by. The pasture all but envelops the cow, creating the unique sense that the viewer, too, is involved in the scene, standing knee-deep in grass and wildflowers.

Cow in Shining Armor

ARTIST: **Anjali Bettadapur**
PATRON: **Zurich Reinsurance**
LOCATION: **Canterbury Green**
(at Broad and Suburban Streets)

Anjali Bettadapur, a fashion designer from India, designs her own line of traditional Indian clothing. *Cow in Shining Armor* is by far Anjali's largest model. The pattern in the cow's armor is inspired by Anjali's love of geometric patterns and hand embroidery.

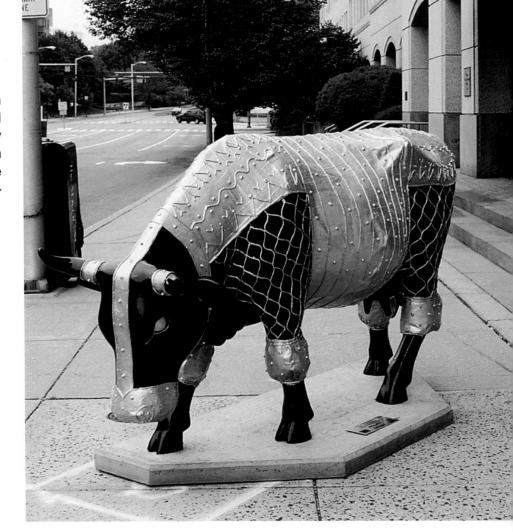

HOLY COWS!: NORSE MYTH

Norse mythology tells how Audhumla, the Great Cow, brought gods and giants into existence by licking the huge blocks of ice in which they had been imprisoned.

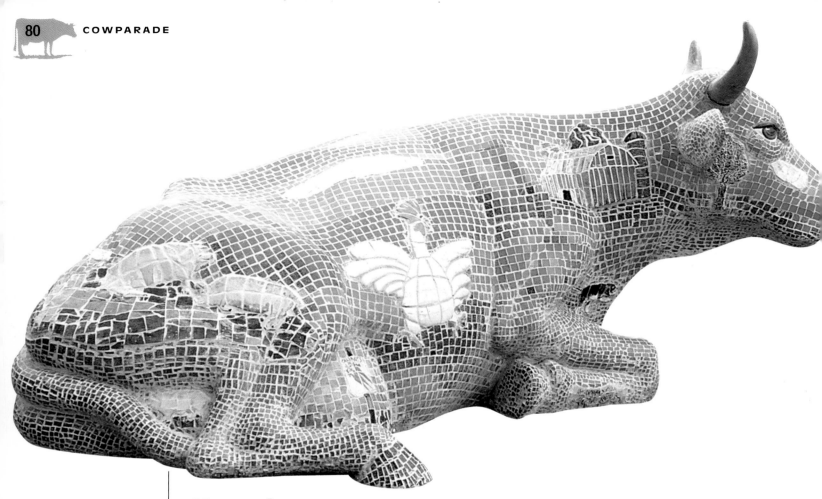

Moosaic

ARTIST: **Debra Krueger**
PATRON: **Clearview Investment Management Inc.**
LOCATION: **One Atlantic Street at Broad Street**

Although Debra Krueger is a ceramicist who has worked with tiles for years, this cow is her first attempt at a mosaic. The cow required 125 pounds of tile and endless reserves of Krueger's patience. The background tiles come from a mosaic company in Vermont, but the special tiles—the pigs, barn, and carrots, for example—were all handmade by the artist.

La Vida Mooca

ARTIST: **Lauren Valente**
PATRON: **Equity Office**
LOCATION: **300 Atlantic Street at Tresser Boulevard**

Stamford High student Lauren Valente caught bits of two television shows the day her mother brought the call for CowParade applications to her attention. The first was a special on Ricky Martin and the recent explosion of all things Latin-American. The second was a few minutes of a movie starring Carmen Miranda. When Valente started thinking about her proposal, she immediately thought of a Carmen Miranda–type cow who wears dairy products instead of fruit in her hat. *La Vida Mooca* sports a colorful floral bikini that Valente made from canvas and painted herself, and a cornucopia of dairy products in her hat. Unable to find strappy sandals in size 2EEE, Valente painted on La Vida's shoes.

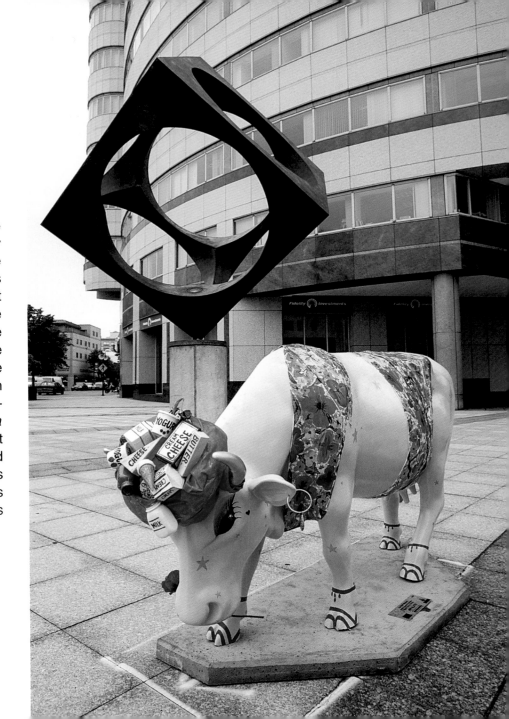

Ferg

ARTISTS: **Bronz & Esposito**
PATRON: **Frank Mercede & Sons**
LOCATION: **Ferguson Library (at Broad Street)**

Looking every bit as regal as their leonine counterparts in New York City, *Ferg* and *Gus* are the bovine guardians of knowledge at the Ferguson Library in downtown Stamford.

Gus

ARTISTS: **Bronz & Esposito**
PATRONS: **Ferguson Library Foundation, Catherine Haala, Construction Consulting Group**
LOCATION: **Ferguson Library (at Broad Street)**

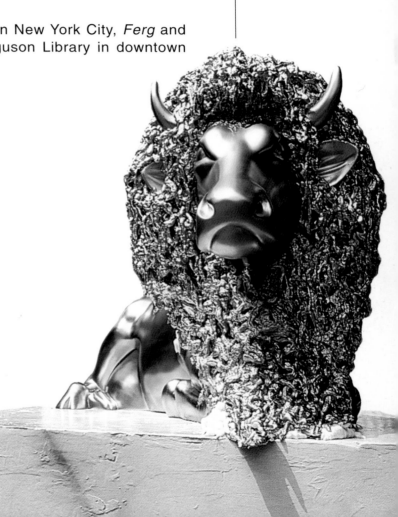

HOLY COWS!: THE BIBLE

Chapter 32 of the book Exodus tells that while Moses was on Mount Sinai receiving the Ten Commandments from God, the fickle Israelites forced Aaron, Moses' own brother, to make them an idol to worship. He made them a golden calf.

As the Israelites were carousing around the idol, Moses returned with the Ten Commandments. The sight of the revelry infuriated him: he smashed the stone tablets on which the Ten Commandments had been written and destroyed the golden calf.

Index Of Sponsors

Index Of Artists

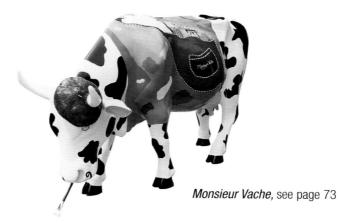

Monsieur Vache, see page 73

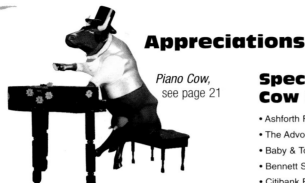

Piano Cow, see page 21

Appreciations

Special thanks to our Cow Sponsors:

- Ashforth Family/ The Ashforth Company
- The Advocate/Greenwich Time
- Baby & Toy Superstore and Hometown Marketing
- Bennett Steak & Fish House and Vitti Construction
- Citibank F.S.B.
- Coldwell Banker Residential Brokerage
- Coastal Fairfield County Convention & Visitor Bureau
- Construction Consulting Group
- Emmett & Glander, Attorneys at Law
- Equity Office
- Frank Mercede & Sons
- Friends of Mayor Malloy
- GE Capital and The K2C Collaborators
- Grade A ShopRite
- Catherine Haala
- JHM Financial LLC & The Richmond Group of Connecticut, LLC
- Juner Properties
- Louis Dreyfus Property Group
- Mario Lodato Real Estate
- Miller & Company PC
- North Castle Partners Advertising & Silverman Realty Group
- People's Bank
- Peppers and Rogers Group
- Deborah & Robert S. Salomon, Jr.
- The Stamford Chamber of Commerce,The Kids Our Future Trust Fund
- Stamford Health System: The Stamford Hospital Neonatal Unit and the Carl & Dorothy Bennett Cancer Center
- Stamford Marriott / Heyman Properties
- The Thomson Corporation

CowParade Stamford 2000 Partners

- Mayor Malloy and The City of Stamford
- Stamford Downtown Special Services District
- Stamford Town Center
- Office of the Speaker of the House, Moira K. Lyons
- The State of Connecticut
- The Advocate/Greenwich Time
- Stamford Marriott Hotel
- Cox Radio, Inc.

Grateful thanks to our multiple Cow Sponsors:

- Stamford Town Center
- Clearview Investment Management, Inc.
- Avalon Communities
- Corcoran Jennison
- Crown Theatres
- The Ferguson Library
- First County Bank
- PanAmSat Corporation
- Purdue Pharma
- Reckson Associates Realty Corp. & F.D. Rich
- Robinson & Cole LLP
- Taurus Advisory Group
- Turner Construction Company

- UBS Warburg
- Worldwide Clairol
- Xerox Corporation
- Zurich Reinsurance

Our appreciation to:

- Bank Street Restaurant
- Friedberg and Smith & Company, P.C
- The Richard & Hinda Rosenthal Foundation
- The Stamford Center for the Arts
- The Stamford Cultural Development Corporation.
- The Stamford Partnership
- Stamford Wine & Liquor

CowParade Operations Team:

- Sandy Goldstein, Executive Director, DSSD
- Lynne Colatrella, Director of Marketing & Special Events, DSSD
- Sharon Cavanaugh, Special Events Coordinator, DSSD
- Ernest Orgera and The Office of Operations & Traffic Maintenance, City of Stamford
- Dan Collelouri, Operations Programs Specialist, City of Stamford
- Lt.Tom Wuenneman and The Stamford Police Department
- Andrew Munce, Cow Doctor
- Chris Fountain, Cowboy